ELLSWORTH KELLY

E. C. Goossen

ELLSWORTH KELLY

The Museum of Modern Art

New York

Distributed by New York Graphic Society Ltd.

Greenwich, Connecticut

Copyright © 1973 by The Museum of Modern Art

All rights reserved

Library of Congress Catalog Card Number 72-95077

Cloth binding ISBN 0-87070-414-1

Paperbound ISBN 0-87070-413-3

Designed by Carl Laanes

Type set by York Graphic Services, Inc., York Pennsylvania

Printed by Eastern Press, Inc., New Haven, Connecticut

Bound by Sendor Bindery, New York

The Museum of Modern Art

11 West 53 Street, New York, New York 10019

Printed in the United States of America

Frontispiece: Ellsworth Kelly, 1972

Photograph by Henry Persche

CONTENTS

THE PAINTER will produce pictures of little merit if he takes the works of others as his standard; but if he will apply himself to learn from the objects of nature he will produce good results. This we see was the case with the painters who came after the time of the Romans, for they continually imitated each other, and from age to age their art steadily declined.

From the Notebooks of Leonardo da Vinci, *translated by Edward McCurdy*

PREFACE

EARLY in the planning of this study of Ellsworth Kelly and his work, it became clear that much in his art was the direct consequence of the uniqueness of his visual experiences quite outside the world of art. Less dependent on current styles than his colleagues and less involved in the more obvious "problem-solving" practiced by many of his contemporaries, Kelly has always been something of an anomaly to his critics. In the course of my many conversations with the artist, clues turned up that upon investigation led to sources and inspirations that might never occur to the casual viewer. Taking shape behind the work was a pattern that had commenced in his childhood, continued in his maturity, and, because of the reflexiveness of his procedure, is still evolving.

A conventional, formalistic study was therefore not enough. A critique lacking awareness of Kelly's visual biography could only attempt to insert his art into, or oppose it to, fashion. But since the quality of his art and the insistence of his career made fashionability a minor consideration, I felt that those for whom his work has a strong appeal would be best served by an account of its genesis and its preoccupations. Thus the biographical approach bordered on what the French call an *explication de texte*—that is, a revelation of the multivarious things that have gone into the work.

Certainly this study may appear to be a veritable potpourri when the Isenheim Altarpiece, the 603rd Engineers Camouflage Battalion, the icons of a Muscovite painter named Rublev, the architecture of Le Corbusier, and the birds of Audubon are all mixed together in the same visual history. Nevertheless these are the crucial though disparate elements that have merged to become Kelly's aesthetic. Even his most recent and thoroughly abstract work is directly traceable to and consistent with the earliest characteristics of his vision.

Obviously a book of this nature could not have been completed without the information provided by a number of Kelly's associates and friends. Among those whom I must thank for affirming or correcting my impressions of various periods in his development are Ralph Coburn, Anne Weber, and Jack Youngerman, for their recollections of Kelly in Paris, Sanary, and Coenties Slip. I must also thank Dr. Frederic Fox, who supplied me with his official history of the 23rd Headquarters Special Troops, of which the 603rd Engineers Camouflage Battalion was a part, and Alan Wood-Thomas, formerly a member of the 603rd, whose memories of the camouflage unit interlocked with Kelly's own. Jane Fluegel of The Museum of Modern Art staff is also to be cited for her coordination of the text, collation of the footnotes, and gathering of many of the illustrations. And finally, of course, my largest thanks go to Ellsworth Kelly himself for giving many hours of his time, making his records and work available, and contributing in every way to the completion of this book.

E. C. Goossen

7

Throughout the book, measurements in captions show height preceding width; for sculpture, a third dimension, depth, appears. Works by Ellsworth Kelly for which no ownership is given are in the collection of the artist. Reproductions in Diane Waldman's *Ellsworth Kelly Drawings, Collages, Prints* (Greenwich, Connecticut: New York Graphic Society Ltd., 1971) are cited in captions by the author's name and the plate number.

ELLSWORTH KELLY

CHILDHOOD

ELLSWORTH KELLY, the second son of three, was born on May 31, 1923, to Allan Howe Kelly and Florence Githens Kelly at Newburgh, New York. His father, of Scotch-Irish and German descent, was an insurance company executive; his mother, a former schoolteacher, came from Welsh and Pennsylvania-German stock. Both families, in previous years, had been established in the area between West Virginia and southern Ohio. Kelly's paternal grandmother's name was Rosenlieb, and his other grandmother was a Stegner: a heritage on the whole that has perhaps some bearing on the Northern character of his art.

When Kelly was born, his family moved to New Jersey, where they lived in a number of places in and around Hackensack. Kelly recalls that his mother moved the family to a different house every year. Some of his strongest memories, however, center in Oradell, a town of about 7,500 inhabitants situated near the Oradell Reservoir. It was on the shores of this body of water that Ellsworth, having been introduced to bird-watching by his grandmother Rosenlieb, was able to train his eye and to develop a passion for form and color. He had learned the names, colors, and shapes of local birds very early, at about eight or nine, a study he continued in later years with the help of the works of Louis Agassiz Fuertes and John James Audubon. The latter in particular has had a strong influence on Kelly's art throughout his career. It was probably also on the lake shore, among the reeds and weeds, that his accurate eye for nature's shapes was sharpened (later to be directly exploited in his plant drawings) and his appreciation of the physical reality of the world was born.

It is worth speculating that close acquaintance with the black-throated blue warbler and the redstart and all the other two- and three-color birds is traceable in the two- and three-color paintings Kelly is best known for; and that as a kind of boy naturalist, out of doors all the time, almost constantly alone—he was, he says, a "loner" who did not talk early or very much and even had a mild stutter into his teens—Kelly's independent character, both as a person and as an artist, was formed well before puberty.

What he was doing in art during this early period is not well documented; in his family's moves from

John James Audubon, *American Redstart,* August 13, 1821
Watercolor, 19⅛ x 12 inches
The New-York Historical Society

house to house, most of the evidence has disappeared. There are recollections, mostly of visual experiences: for example, a vivid memory of a dark summer evening when he was drawn toward a lighted house window because for the first time he saw it in terms of areas of light and color; a crushing (but perhaps strengthening) rebuff by a teacher in the third grade who found him rubbing crayons on a piece of rough manila paper in order to get the exact color of blue he wanted so that he could cut out his drawing of an iris and paste it on another sheet. She said: "We're not here to make a mess. Go stand in the corner."

The elementary grades and high school were apparently conventional experiences. Art classes, such as they were in the late-1920s and 1930s, were undoubtedly conducted along the lines of an Arthur W. Dow–influenced curriculum.[1] Kelly was, in fact, during his high school years divided as to whether to go into theater or art. His talent was to some degree recognized by his art teachers, particularly Evelyn Robbins in high school. On graduation his parents, confronted with the theater-or-art problem, accepted a practical solution. They would support, financially and ideologically, solid technical training in the applied arts at Pratt Institute in Brooklyn.

Kelly went to study and live in Brooklyn in the fall of 1941. He recalls only one instructor, Maitland Graves,[2] who he felt gave him some of the training he wanted. After a year and a half at Pratt, the Second World War took precedence. Having volunteered for the Army, he was inducted on New Year's Day, 1943.

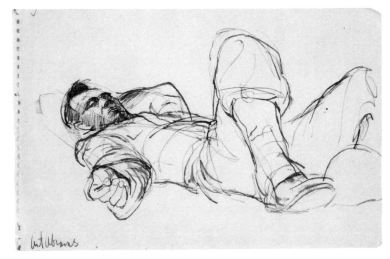

Art Abrams, 1944
Ink on paper, 5¼ x 8¼ inches

THE ARMY YEARS: 1943–1945

WHEN KELLY entered military service, he requested assignment to the 603rd Engineers Camouflage Battalion, as it was perhaps natural for an artist to do. Inducted at Fort Dix, New Jersey, he was permitted to wait there several weeks for transfer orders; none came, so he was summarily sent off to Camp Hale, Colorado, to be trained with the mountain ski troops! Kelly, who had never been on skis in his life, made the best of it; and when his transfer to the Engineers finally came through six or eight weeks later, he actually left for Fort Meade, Maryland, with some regrets. He had rea-

son for some sadness; from the relaxed atmosphere of a beautiful mountain camp where officers and men fraternized freely, he went to one of spit-and-polish discipline in the shadow of the nation's capital and at the center of its military machine.

The 603rd Engineers Camouflage Battalion was, according to official records, "composed mainly of artists from New York and Philadelphia with an average IQ of 119."[3] At full strength it comprised 28 officers, 2 warrant officers, and 349 enlisted men, the last of whom included Kelly. He remained a buck private throughout his military career; when promoted to private first class, he would not bother to sew the little stripe on his sleeve.

As a lowly private, only twenty years old, with as yet but three semesters of formal training in art, his assignments in the studios where camouflage methods were designed were relatively menial. Since the 603rd was as much a propaganda unit at this time as a unit being trained for combat duty, it issued quantities of posters for distribution to regular fighting outfits such as the tank, supply, and artillery corps. These posters, made by the silkscreen process, were issued in groups of a dozen or so, offering a short visual course to the uninitiated in concealment techniques. The subject, camouflage, was broken down into elemental terms, sounding like—and probably partly derived from—the foundation course at the Bauhaus, though the Father of Modern Camouflage is usually acknowledged to be the American painter Abbott H. Thayer (1849–1921).[4] Each poster dealt with a subject such as Texture, Color, Shadow, Blending, and Shape; they were meant to demonstrate quickly the importance of each to the disruption of the normal color-and-form patterns of such three-dimensional targets as trucks and jeeps, tanks, guns, supply dumps, and bivouac areas in order to blend them into the visual background.

Except when Kelly's battalion was on maneuvers in Louisiana or Tennessee with the First Army, engaged in actual fieldwork erecting camouflage nets woven with oznaberg (a cheap, thick cotton fabric cut in strips), he was largely engaged in making posters. He was taught the silkscreen printing process soon after joining the 603rd. Eventually he was assigned to cutting the stencils; the designs, however, always came from "above," possibly from the camouflage headquarters group at Fort Belvoir, Virginia, under the command of Colonel Homer

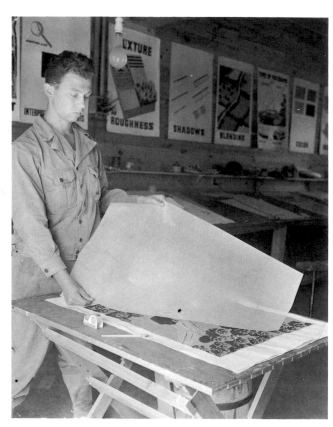

Kelly sorting silkscreen prints
of camouflage propaganda posters issued by
the Engineers Camouflage Battalion, June 1943

Saint-Gaudens, son of the famous sculptor Augustus Saint-Gaudens. Kelly recalls his aversion to the designs because they were so like 1930s advertising art, meaning that their conventionalized literalism was neither communicatively effective nor aesthetically satisfying. In color of course they were dull, since the current theory of camouflage was based on the generalization that natural hues were related to the so-called earth colors, variations of sienna and umber with small additions of the primaries; and the posters demonstrated the color theory as part of their message. Unfortunately, in the olive-drabness of the average military environment, the posters tended to camouflage themselves.

In January 1944 Kelly's battalion was moved to Camp Forrest, Tennessee, where it was attached to the 23rd Headquarters Special Troops, a new unit to be devoted entirely to deception. While the older methods of camouflage were to be continued, especially by other areas of the service, the 23rd's mission was literally to reverse the philosophy of concealment. As former Sergeant Alan Wood-Thomas of the 603rd puts it, the mission was "shifted to dummies—making appear, instead of making disappear,"[5] which meant the creation of fake armies to draw the enemy's resources and fire away from the real ones.

The camouflage battalion learned to construct and deploy trucks, tanks, and guns made of chicken wire and plywood and then to conceal them with official-looking but purposely ineffective "fishnets" bedecked with oznaberg, the shadow-making and -breaking material. Later rubber dummies were issued, to be inflated in place and then "hidden." The main effort of the whole 23rd Headquarters Special Troops, however, soon became radio-message deception, the broadcasting of amplified recordings of armored divisions on the move, a ruse often employed by sound trucks in the last months of the war in France.

Kelly's outfit went to England early in May 1944 after only two months of training for its new mission. Their first bivouac was on a manorial estate at Wellesbourne, near Stratford on Avon. Maneuvers with the dummies continued for another six weeks, and then on June 19, the 603rd was loaded on LSTs and carried to France. During the summer the unit engaged in various supporting deception tasks near Rubercy and Le Fremondre, assisted in the siege of Brest, going on, as the Allies advanced,

to Torcé and Mauny and then spent thirteen days in early September at Camp Les Loges, a vacated French barracks in Saint-Germain on the edge of Paris.

Kelly could not at this time speak French; moreover his shyness and his tendency to be a loner meant that Paris for him was primarily a visual experience. His buddy, Bill Griswold, a student of architectural history, could speak the language and was one of those hundreds of G.I.s who sought out Pablo Picasso. But he did not take Kelly along because he "would not look good in a drawing room." (Picasso, in his cold studio in rue des Grands Augustins, had no "drawing room.")[6] Everybody went into the city from Saint-Germain nearly every day looking for pleasure after privation. Kelly walked the streets, looked and looked at the architecture, the churches, and the parks (most of the museums were closed), and was numbed by the experience of the great city. Unfortunately, only a few of his sketchbooks from this period still exist, so there is no complete record of just how he was seeing what he looked at—until November and Luxembourg.

The Paris spree was soon over, and the war began again for the 603rd. In late September the battalion, following the advancing front line, was stationed next in Bettembourg, and then in the city of Luxembourg itself. The 23rd Headquarters remained there until April of the next year and the end of the war; but the 603rd stayed only until the German counterattack across the Moselle on December 16 (the Battle of the Bulge), and then was variously moved around, to Doncourt, Verdun, and Briey, as well as to points near such battle areas as Metz, Thionville, and Bastogne, where they conducted two- and three-day operations.

The sketchbooks from November and December are the work of a mature student artist with occasional flashes of brilliance. Like all work by soldier-artists, they are erratic in subject and quality, indicating for the most part only a desire to stay in practice and in some way to relate the past to the present. Remembered skills predominate; Kelly's sketch of a bunkmate (*Art Abrams,* page 11) could have been published in *Life* as an accompaniment to Ernie Pyle's war reports. A sketch of the cathedral in Luxembourg is an exercise in documentary perspective. However, the gouaches of landscapes near Metz and Briey are the begin-

ning—in a necessarily crude way—of the organization of an exotic, natural scene into an art idea. But the portrait of *Janny* (at left), a friendly adolescent girl, done on Thanksgiving Day, 1944, is prophetic of a transition from a learned, illustrational style to the equation of form with feeling that would preoccupy him from then on.

The 603rd Engineers Camouflage Battalion was no longer needed for deception operations after the Allies broke the German defenses and raced for Berlin. The war was essentially over. The unit was assigned to administer several displaced persons' camps in the area between the Moselle and the Rhine near Idar-Oberstein. Here Kelly made pencil and pen-and-ink drawings of a number of the camps' inmates, people from Central Europe who had been used by the Germans as forced labor.[7]

In early summer 1945 the 603rd was shipped back to America and ultimately disbanded. One of the most important things that had happened to Kelly during these two and a half years at war was his exposure to military camouflage, which is, after all, a visual art. This involvement with form and shadow, with the construction and destruction of the visible, was a basic part of his education as an artist. In various ways it was to affect nearly everything he did in painting and sculpture a few years later, though at the time it must have seemed totally unrelated. (See Appendix: *Kelly and Camouflage,* page 115.)

THE BOSTON YEARS: 1946–1948

BECAUSE HE had been in a camouflage unit and in the company of a number of artists of varying propensities and interests, Kelly had been closer to his prime concerns than many other soldiers. Moreover he had served in France, and something of its artistic culture had touched him, however lightly. Yet, having no real knowledge of what was going on in New York, how vital a scene had begun to develop there, and wanting something more educationally substantial than the Art Students League but having been disappointed with Pratt, he selected the School of the Museum of Fine Arts in Boston.

The benefits of the G.I. Bill were of course available to him as a returning veteran ($75 each month

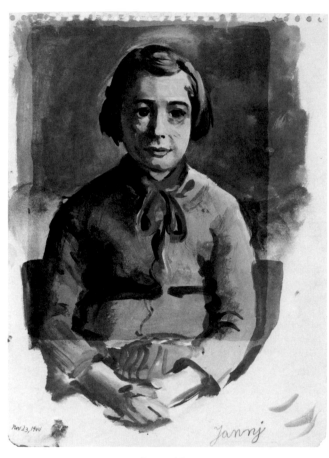

Janny, 1944
Gouache, 12 x 8¾ inches

plus tuition and supplies). He was also able to augment this amount by obtaining a studio and a room rent-free at the Norfolk House Centre, a settlement house, in exchange for teaching two evenings a week. These classes were composed of elderly as well as young people from the Roxbury section of Boston. Settlement-house teaching is very much alike everywhere: a combination of social therapy and the satisfaction of a longing on the part of most students to add a little color to otherwise drab lives. Kelly recalls only one student vividly, a middle-aged woman whose work was thought totally inept by the others because it was naïve, but which he found most imaginative.

The curriculum at the Museum School was of the usual sort, drawing and life classes, painting, design, and sculpture, as well as the compulsory two hours a week of art history, resented as ever by most of the student body. Kelly, however, got A's in all his courses, including art history, which he really enjoyed. In fact he spent every spare hour in the Museum collections and became a regular weekly visitor at the Fogg Museum at Harvard and the Isabella Stewart Gardner Museum on the Fenway.[8] Some of this seriousness may be attributable to the maturity brought about by his years in military service, an interruption in the progress toward life's goals felt so deeply by many ex-G.I.s. Making up for lost time, the pure joy of serving one's own ends, and the added years of age were the beneficial by-products of an otherwise unfortunate experience. As an example of this seriousness, when asked in design class to pick a scene from Stravinsky's *Petrouchka* and to create a set or a costume for it, Kelly stayed up several nights and completed designs for the entire ballet, which he laid out on a folding screen. For someone who had spent many winter nights without sleep, setting up dummy tanks, trucks, and guns in front of the German lines along the Moselle in Luxembourg, such a sustained task (setting aside the difficulty of making the inherent aesthetic decisions) was hardly a new or impossible idea of self-discipline.

The Boston Museum School was dominated by the personality of the German-born-and-trained artist Karl Zerbe (1903–1972), who was the head of the painting department. Zerbe was an expressionist who had come to the school in 1937 after periods in Mexico and Paris. Even before he had arrived, however, the school was known as the cen-

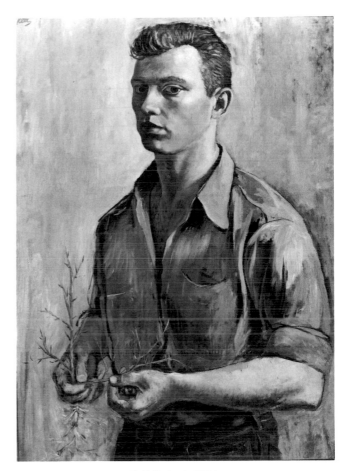

Self-Portrait, 1947
Oil on canvas, 39½ x 27½ inches

superficially in Richardsonian eclecticism. Ultimately, however, Kelly's interest in the style extended more to its details.

During the very first spring (1949) he set out on a trip during Pentecost (that period after Easter during which students overrun Europe) employing the typical means of transportation: bicycle and train. He pursued a westerly loop from Paris, ranging as far south as Saint-Savin-sur-Gartempe and Poitiers, back north and west to Mont-Saint-Michel, and then via Chartres to Paris again. His prime discoveries were the frescoes at Saint-Savin and Tavant, painted in the eleventh and twelfth centuries. Saint-Savin is one of the four churches remaining out of perhaps a thousand that still has a complete cycle of Romanesque religious paintings. And the pendentives of the crypt at Tavant, with their confined but loosely painted figures, suggested once again the possibility of fitting a figure or theme into other than the conventional rectangle. The same kind of problem and its solution was apparent in the *mandorla* on the façade of Notre-Dame-La-Grande in Poitiers (eleventh–twelfth century), where the cat's-eye shape, in relief, encloses the figures in a hollowed-out space.[15]

Kelly's attraction to the Romanesque, sparked by the Catalan apse seen on visits to the Boston Museum, was paralleled by an impulse toward the Byzantine, especially where these two historical styles tend to merge. He had been introduced to the Byzantine style through the paintings and drawings of David Aronson and Bernard Chaet, older students at the Boston school. In Paris, soon after his arrival, he looked up the Byzantine Institute, an offshoot of Harvard under the direction of Thomas Whittemore (oddly enough also the donor of Matisse's *The Terrace,* a favorite painting of Kelly's, to the Gardner Museum).[16] The Institute was in a capacious private building and housed a fine study collection of rare Russian and Greek books, icons, and manuscripts. Kelly, though he was without credentials, either scholarly or religious, was nevertheless admitted to the sacred chambers of the library, where he sat among brown-and white-robed monks, poring over specimens of the collection. It was a cold winter, the Institute was warm, and he went there twice a week. The qualities of Byzantine painting which seem to have affected him most and which appeared in his own work both then and later were the definitive contouring of shapes and the sensuous continuous line, derived particularly from the innovative Russian painter Andrei Rublev (active c. 1410–1420), whom he had discovered even before leaving Boston and whose *Holy Trinity* he admired.[17] Moreover, the general frontality and flatness of Byzantine painting, its conceptualization of the human figure, and its architectonic elements were all appropriate and justifying for any artist in the 1940s trying to recover from the hangover of nineteenth-century representationalism. And, of course, for a time he introduced qualities of the Byzantine and the Romanesque into his figurative drawings and paintings, gradually moving away from his Boston period.

His tendency to search out the elemental aspects of things-within-things, fixing on a shape such as the *mandorla* of Notre-Dame-La-Grande or the curve of a sleeve in Rublev's *Trinity,* became a daily visual preoccupation and a continuous source of inspiration. Sometimes photographs, as well as actual monuments, served his purpose; for example, he could be attracted to the almost random two-color patterning in the stonework of such a building as Tarbes Cathedral.[18] But most often the derivations were things actually seen, sketched, and frequently "banked" in this form until there was a use for them in another context, often scarcely recognizable in relation to their sources.

The study of the Byzantine and Romanesque was, nevertheless, study; a means to an end, not an end in itself. It was an effective way of finding the relation of art to life and of past art to present needs. But the contemporary art of Paris was of course the real challenge.

In those difficult postwar years the figures of Picasso, Matisse, Braque, and Léger still loomed over the Seine. School of Paris painting was ubiquitous, though tired. The only new thing that seemed to have happened in France during the war was the rediscovery of Wassily Kandinsky, a phenomenon paralleled in New York. The causes for this revival are complicated but in general seem to imply the need for a return, though roundabout, to a pre-Cubist idea of art. It was not that Kandinsky himself was promoted to the rank of a great artist; it was rather that the peculiar combination of Impressionism and Fauvism in his work prior to 1914 became for the first time visible as an alternative to both Cubism and Surrealism (the latter by this

time also a largely worked-out vein). Kandinsky's Expressionism, moreover, seemed, at the outset at least, more open to personalization than that of the other major contender for a route out of the doldrums—Piet Mondrian's pure plasticism. Yet those who had long since chosen Mondrian's way constituted in Paris, as well as in Antwerp, Amsterdam, and New York, a loyal enclave, though the first important Mondrian show in Paris was not mounted until 1957 by the Galerie Denise René. Mondrian's first and only one-man show during his lifetime (1872–1944), on the other hand, was held at the Valentine Gallery in New York in 1942, shortly after he had come to America.

André Masson, the French abstract Surrealist, said that when he returned from New York in 1945 "geometric idealism (figurative or nonfigurative) was still in the ascendant. Surrealism, automatism, nonetheless retained a subterranean influence. But around 1948 a certain change could be felt in the air. A sort of naturism (and not naturalism) haunted the minds of a few individuals. They felt a need to move away from mechanical rigidity of composition, from the obsession with volume, from overdecorative line—and also from a dream imagery tending toward academicism."[19]

It is hardly to be assumed that Kelly, recently from Boston, was sophisticated enough in Parisian art-world nuances to have analyzed what had recently happened and what was happening around him. It *is* reasonable to assume, however, that he was affected by the ambience as it was expressed in such exhibitions as those devoted to Kandinsky and Wols at the Galerie René Drouin, and the appearance of a whole new generation of "expressionist" anti–School of Paris painters in galleries around town.[20] But he was affected negatively. He says, rather tersely: "I liked Kandinsky—but I always wanted to make things out of what I saw." His predilection for contour drawing, for the clarity of shape in Byzantine and Romanesque art, was offended by the new expressionism, which seemed to him relatively formless. Even in this period when he was still working through a Beckmannesque expressionism himself and obviously yearning to break that bond, he could not do so until he found a subject matter that could be fitted to his prejudices.

These prejudices were strong and Boston-derived. He says: "There was no Surrealism in Boston." And

pure abstraction, such as that represented by de Stijl and Mondrian, was unknown except in design courses and was not legitimately convertible to painting or sculpture. He had seen some Mondrians in The Museum of Modern Art in New York, but they had had little appeal for him. In the winter of 1948/49 he made an abstract painting from the checkerboard design on the end of a Seine barge and then destroyed it because he could not yet accept complete abstraction.

Something happened during the summer of 1949, however, that had a liberating effect on Kelly. Ralph Coburn, a friend from Boston, came over to France in June for a vacation. Coburn, now a painter and a designer for The M.I.T. Press in Cambridge, Massachusetts, had heard about automatism and various other devices that had become popular among avant-garde artists in New York. The New York artists had in turn got them from the Surrealists, especially Masson and Matta, who had passed the war years in America.

Automatic drawing is a method for arriving at an image without looking at the sheet of paper upon which it is drawn. It eliminates the traditional movement of the eye back and forth from the subject to the drawing, involving eye, mind, and hand in a system of checks and balances. It achieves results which are often very startling to the drawer, but which, more often than not, are similar in character to all other such drawings. The mixture of expertise, innocence, and accident can suggest an unearned creativity. Often the result is superficially like the work of Klee and Picasso as well as that of children and psychotics. Its value to the art of the 1940s was mainly to break up overly rigid concepts of what art was or could be, and to indicate that not all of art's sources are rational, controllable, or predictable. As such it was a kind of contemporary therapy, the results of which would still have to be judged in the work, and not by the technique itself.

Kelly was intrigued by Coburn's demonstration of automatic drawing, and during the summer of 1949 they both practiced it. Several such drawings appear in Kelly's sketchbooks from this period. The result was primarily a loosening of his drawing style and a broader acceptance of what might constitute a work of art. A year later he would be able to indulge in another process that had been devised by the Dadaists and Surrealists in the second dec-

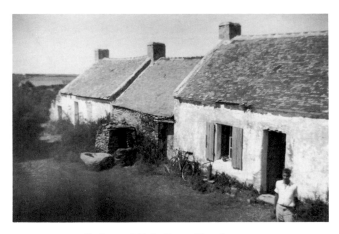

Cottage at Belle-Ile-en-Mer, France,
with Kelly's friend Ralph Coburn in foreground, summer 1949

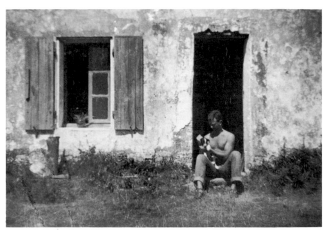

Kelly on doorstep of cottage, Belle-Ile-en-Mer,
with dog Uki, summer 1949

ade of this century, the use of chance for the ordering of pictorial elements.

This same summer Kelly and Coburn visited the late Gertrude Stein's companion, Alice B. Toklas, and saw the Stein collection. The picture Kelly studied most intensely while there was Picasso's *Student with a Pipe* (winter, 1913/14), a collage composed of oil, charcoal, paper, and sand on canvas.[21] It is probable that it was the shape and flatness of the student's *faluche* (beret), cut out of brown paper and pasted on the surface, that most attracted him, similar as it was to the shapes he had found in Russian Byzantine paintings. The collage method was also to take on prime importance in his work during the next few years. It was, oddly enough, also a method used by Audubon in preparing the plates for *The Birds of America,* long familiar to Kelly.[22]

For a couple of weeks Kelly and Coburn shared a typical Breton-seaman's cottage situated on Belle-Ile-en-Mer, an island that was "all gray and yellow." Coburn says that Kelly, who was always looking at everything and seeing things that no one else saw, "taught me how to see." The starkness of this barren world, devoid of color and with relatively little obvious "form," Kelly found stimulating and challenging. The result (upon his return to the island alone in August) was a series of extraordinarily inventive drawings and paintings based on such things as seaweed, pebbles, the window in his house (page 22, leading to a group of "window" paintings), a golden sunburst atop the village church, and even a roadside marker (opposite).[23]

T. E. Lawrence once pointed out that the desert spawns religions; cities are replete with subject matter to the point of distraction. Kelly's eye, like Georgia O'Keeffe's in West Texas, was honed in the wilderness. The human figure and the set-piece of previous art became unnecessary. He had to turn neither to the dream world of Surrealism nor to "geometric idealism" to find points of departure or connections between the world of reality and the world of art. With such an eye he would never have to indulge in pure fancy or abstract ideas to arrive at an "abstract" art.[24]

Upon returning to Paris that October and having painted the required nude for readmission to the Beaux-Arts (and thus to earn his G.I. stipend), he found the city full of hitherto unnoticed things to look at. His sketchbooks are full of notations of

Kilometer Marker, 1949. Oil on wood, 21½ x 18 inches.

This little picture bears the same relation to the formal characteristics of Kelly's whole body of work as a course in Basic English does to the English language. Its subject is taken from the visual environment, but that subject is so simple in itself, and so essentialized in the painting, that we need not identify it in order to know its qualities. It could be the arch of a doorway or window as easily as a kilometer marker. The top of the marker has been made tangent with a "horizon" line, which is like the bottom of a lintel over an arch, and so the same visual tension appears. And since the tops of markers in France are painted down to a point where curved and straight lines meet, creating an effect like that of the tympanum, Kelly has not distorted the truth for ambiguity's sake. And regarding the horizon, in Belle-Ile the flat line of the sea might well meet the crest of the curve of the marker when such a marker is drawn from a sitting position.

The people who see only the geometry in Kelly's painting make a mistake. He is a "pre-Euclidean." The formalities of geometry and its abstractness are of no consequence to him either at the inception of an idea or in the final result. It does not take a geometrician to see the curves and straight lines in nature. The moon does not belong to mathematicians, and architects built buildings long before Euclid. Indeed, the special freshness in Kelly's art lies in his reliance on his own vision, and the only "system" he refers to is the one he has devised himself by simply looking at the world. It includes straight lines, angles, regular and parabolic curves, flat planes, and pure colors. The closest he has come to systematizing his ideas about how these things work "abstractly" is in a series of studies he made for a book project in 1951 (Waldman, plates 49–54); he later abandoned it, apparently because it was leading him into a kind of thinking he actually deplored.

Kilometer Marker has certainly been a prophetic picture. One has only to compare it with *Rebound,* 1959 (page 70), and *Red Blue Green,* 1963 (page 55), to see how it initiates both forms and circumstances: the tension between curve and straight line, the precise clarity of the shapes, including the "negative" spaces on either side of the central shape, the horizontal panellike rectangle at the top and the vertical rectangle of the lower part of the marker. *Kilometer Marker,* although it belongs to the grayish-white pictures of this period, is essentially a two-color painting, pale yellow and white. Two-color combinations make up the greatest part of Kelly's work over the years.

Kelly has stated that he had studied Paul Klee during his early years. *Kilometer Marker* has a parallel in *The Mask of Fear,* 1932 (Fig. 17, page 107). Klee may have also used one of these ubiquitous distance markers as the source of his basic image. A comparison of the two is revealing. Klee plays with the shape, moving it toward humanization in anthropomorphic terms, Freudian, religious (the arrow to heaven), and surreal. Kelly, however, seems interested only in those visual properties of the subject that can become visual properties in the painting.

opposite: *Window I*, 1949. Oil on wood, 25½ x 21 inches.

right: *Window, Museum of Modern Art, Paris*, 1949. Oil on wood and canvas, 50½ x 19½ inches.

Windows are frequent subjects in Kelly's early work and are structurally paralleled in his later work. A sketch in gouache preceding *Window, I*, 1949 (Waldman, plate 23), is a literal rendering of the six panes of a typical French casement window, emphasizing the black framing of the sash. The gouache and a sketch (Fig. 16, page 106) were done in Belle-Ile during the summer of 1949; the painting, a modification to the point of symbolism, was done in Paris in the fall. In 1949 and early in 1950, Kelly wavered between recording exactly what he saw and seeing his subject in terms of something else, most often the figure. His wood and string cutout reliefs (page 24) and works derived from a French floor-toilet are conceived, Picasso-fashion, as "figurative." Yet he also made a number of paintings and objects that were direct translations of the subject in a kind of ultra-realism. The most spectacular of these, even in its miniaturization of the subject, was *Window, Museum of Modern Art, Paris*. It is virtually an architect's mock-up in scale even though Kelly never seems to have actually measured the original (Fig. 33, page 110). It has some of the flavor of the fake tanks and trucks built by his wartime camouflage battalion to deceive the enemy.

Window, Museum of Modern Art, Paris, a "construction," is prophetic, not only of the development of Kelly's own work in panels, reliefs, and sculpture, but also of Pop art and primary structures of the 1960s.

This work is also a kind of "ready-made," not in the Duchampian sense, where the original object is simply taken out of context and given the aura of "art," but in the sense that the subject apparently offered all proportional and compositional interest in and of itself. Moreover the work and his manner of making it eliminate the problem of illusion. A low-relief subject is given a low-relief treatment. It predicts Jasper Johns's Flags and Targets, in which the subjects' real dimensions are totally compatible with the flatness of the canvas surface.

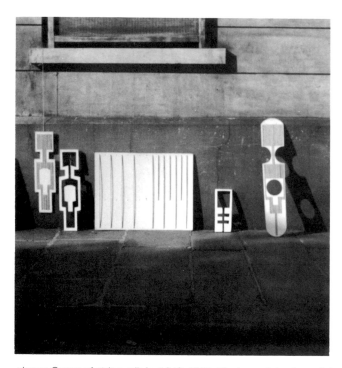

above: Group of string reliefs, 1949–1950. Photograph by the artist.

opposite: *Saint-Louis, II*, 1950. Oil on cardboard mounted on wood, 22 x 39¼ inches.

In 1950 Kelly occupied himself largely with reliefs based on the sketches he was accumulating in his notebooks. His eye was obviously directed toward some of the most unlikely places for subject matter, and he was discovering things he could use all around him. Fascinated with a wall near his hotel-studio in Paris, he made a kind of replica of it. The revetted stone surface, so common in Paris, was simulated by gluing strips of thick cardboard on a wood panel, spacing the pieces just far enough apart to create real shadow lines like those on the actual wall. He painted it white and called it *Saint-Louis, II*. The picture is a combination of abstraction and an ultra-realism like that of William B. Harnett.

patterns provided by shadows and stains, by changes of color from one material to another,[25] of openings in walls, of doorways and windows, and of chimneys on the outside of walls.[26] Many of these would wait a year or more for exploitation in paintings or constructions, and others provided themes that would be reworked again and again in years to come.

Coburn had gone south when his room in the Parisian suburb of Saint-Germain-en-Laye had become untenable because of dampness. At his invitation, Kelly went to visit him over Christmas in Sanary, a resort town of 2,700 inhabitants on the Côte d'Azur, thirteen kilometers from Toulon, a site in earlier days favored by D. H. Lawrence, Katherine Mansfield, and Aldous Huxley. This trip was just a taste of the south of France, to which Kelly was to return in 1951 for a longer stay. It included a pilgrimage to Cap d'Antibes to see Picasso, but once again, perhaps, Kelly's shyness intervened. The nearest he got was a short exchange with Picasso's companion, Françoise Gilot. However, several sketches of the harbor at Antibes resulted in paintings the following year.

In the spring of 1950, his G.I. Bill used up, Kelly survived as best he could with some help from home, living on his high floor in the Hôtel Bourgogne on the Ile-Saint-Louis. Here he designed his first reliefs, cutouts in wood, made for him by an *ébéniste*. Their internal patterns are laced with string and thus related art historically to early Constructivist practice (Naum Gabo's translucent thread pictures and sculptures) but strangely enough even more related to the punched-card-and-yarn pictures made in every kindergarten class in America in the 1920s. The latter seems a likely latent source since Kelly had at this time very little direct experience with Constructivist art.

During the same period he made several pieces with twine laced through holes or sewed on canvas, using the conventional rectangular field; one was taken from the window pattern, and another was based on a driveway gate that had vertical metal stiffeners welded to its solid iron sheets.

This fascination with the literal presentation of the drawn pattern led to other methods. In *Saint-Louis, II* (opposite), for example, strips of cardboard were bevel-cut and pasted on board and painted, letting the "incised" lines with their depth and shadow create the image. This was actually a re-

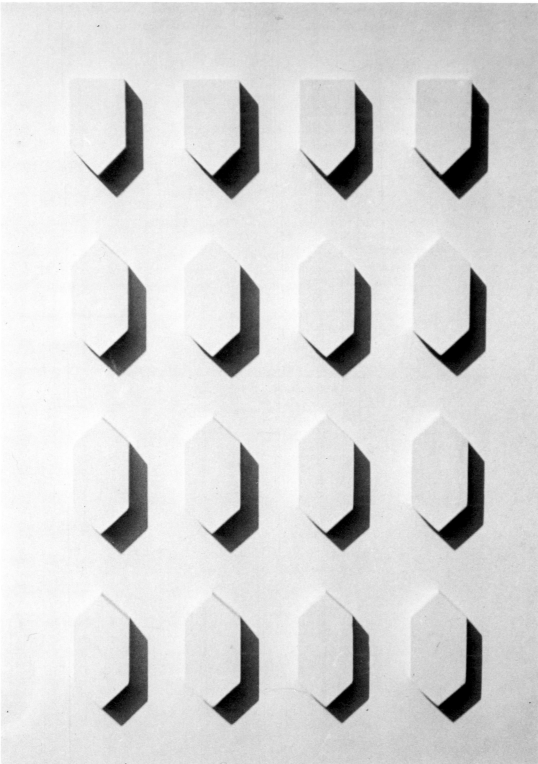

opposite: *White Relief,* 1950. Oil on wood, 39¼ x 27½ inches.

right: *Relief with Blue,* 1950. Oil on wood, 45 x 17½ inches.

The design for *White Relief* came from a *pochoir* (stencil) he had found in a shop. The idea for the cutout pieces of wood glued to the panel undoubtedly came out of Arp, but the blunt grid organization came from the *pochoir.* It is probable that he was drawn to the latter because of his experience as a stencil-cutter in the camouflage corps. By lopping off the peaks of the top row of the protruding pieces, he has given the relief an orientation without juggling things around. If viewed with eyes half-closed, the shadows become flat planes and recall certain shapes he was to use in the late 1960s.

Jean-Louis Barrault was offering *Hamlet,* in Gide's translation, in his repertory at the Théâtre Marigny in 1948–1950. The stage set was very simple, using virtually nothing but black and gray curtains that were opened and closed in various depths and widths for changes of scene while colored lights changed the mood. One arrangement in particular caught Kelly's attention when he went to see Barrault's production. He made a little sketch and later translated it into *Relief with Blue.* The stylized and truncated curves of the ''drapery'' at the bottom appear in any number of subsequent works. The bright, light blue of the rectangle on the plane back of the white area is the first appearance of this kind of color, so typical in later years.

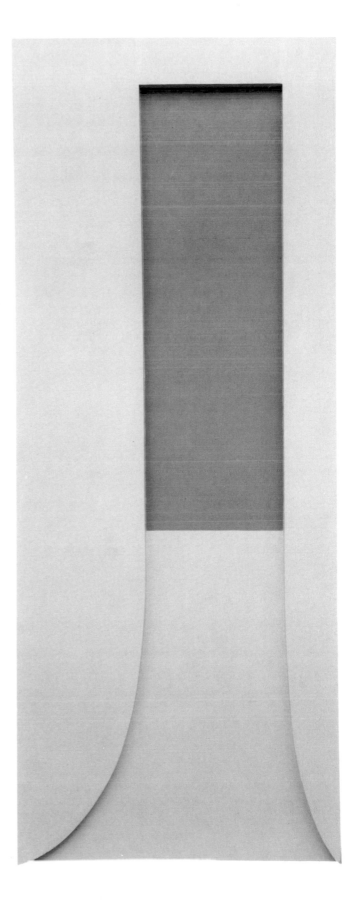

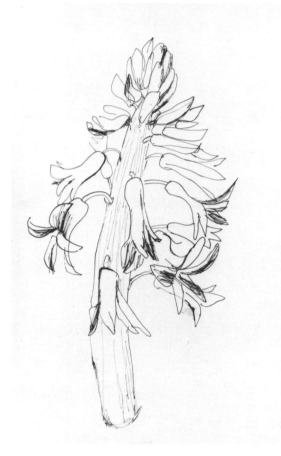

Hyacinth, 1949
Ink on paper, 16½ x 12 inches

presentation of the facts: the stone face of the subject wall was creased in exactly the same fashion.

He had, in this period, moved a long way from the brushwork technique of his school days. The expressive textural qualities of manipulated thick paint had been translated into literal renderings with thread and incised lines of nature as it exists. Collage also began to interest him as an intermediate step toward finished paintings. In one painting he reproduced a collage he had made from *objets trouvés:* a gas-bill receipt, a pink handbill, and some green paper, all found in the gutter. While these creations cannot be considered new additions to modern art, the processes he was selecting and personalizing were consistent with his development, and all were employed with originality and finesse. In the early spring of 1949, perhaps because of these moves toward greater abstraction and the abandonment of the human figure as a subject, he had begun to make drawings—formally such, not sketches—of plants. The first of these were of a hyacinth (page 28) he had brought home to his hotel-studio. For many years thereafter, plant drawings appeared as a regular part of his work. (See *The Plant Drawings,* pages 96–97).

Kelly was still primarily a loner even though there were many American artists in Paris.[27] His closest friend in those years, aside from Coburn, was the young American painter, Jack Youngerman, whom he had met during his first term at the Beaux-Arts. Youngerman describes Kelly as even then "a person of great probity and concentration," whose ideas about art were always impressive and serious. But while Kelly never did get French under control, his friend, who was much more socially involved (he was soon to marry Delphine Seyrig, a budding actress who eventually played in *Last Year at Marienbad*), became thoroughly at home with the language.

Some more temporary friendships nevertheless helped to bring about a modicum of contact with the inner circles of the French art world. The Swiss artist Jürg Spiller, whom he met by chance and who perhaps had mistakenly read Kelly's painting of the moment as more closely related to Constructivism than it actually was, brought him along on a visit to Georges Vantongerloo. Kelly's account of this first encounter indicates fully his lack of rapport with the principles to which the Belgian artist had devoted his life (1886–1965). Vantonger-

loo was a lonely man, a member of the first generation of the de Stijl group, who still felt it necessary to harangue his visitors with the old aesthetic battle songs. After an hour or so of monologue, he played the trumpet for another hour; then he showed them some of his more recent works, explaining at length his mathematical theories. "He made me understand," Kelly recalls, "that *his* kind of paintings had to have reasons. I was glad that mine didn't." He realized, in this doctrinaire atmosphere, how much he liked Pierre Bonnard and Henri Matisse, even though he would not want to imitate them. Kelly nevertheless respected Vantongerloo and visited him several times more with other friends.

One evening after dinner Spiller took Kelly around to Alberto Magnelli's studio near Alésia. Magnelli (1888–1971), who is not as well known in the United States as he should be, was one of the first of the geometric abstractionists; his work in this manner dates from before 1915. Though Kelly does not recall having learned anything very specific from the older man during a tour of the studio, he was impressed not only by Magnelli's grace and charm, but by the sense that he was in the presence of an important artist. Indeed, this sense apparently made him nervous, and on the way home he was inexplicably sick in the street.

A visit to one of Francis Picabia's famous Sunday soirées was of another sort. Here the *maître* was enthroned on a black seat with pillows. Guests approached, were received, and then sent off to look at the art if they pleased. The food and drink —Picabia was known in Paris as a great epicure— were more than excellent. Picabia had recently, Kelly says, repainted all his 1930s pictures in "dots."

These visits to various artists who were already "historical" were social accidents rather than planned maneuvers. They had only the vaguest effect on Kelly's work and seemed to have served more to establish the reality of the artist as such, a matter of no small psychological importance to a young man still afloat in a foreign capital. A visit with Constantin Brancusi in the Impasse Ronsin with Jack Youngerman, on one of the days the Roumanian sculptor held open house, pretty much followed the same pattern. In this case, however, there was perhaps a greater affinity for the man's work and for the kind of example he had set with his life in art. Sidney Geist says, in his excellent study of Brancusi: "With Mondrian he was the first to

create, however guardedly, an oeuvre of systematic formal development, a mode of artistic activity which has recently gained currency."[28] When one reviews Kelly's artistic history and development, a certain similarity to both Mondrian and Brancusi appears. Like their art, his is reflexive. There is the same kind of accepted self-knowledge, of cleanliness of approach and consistency in the refining of previously established themes and forms. There are also certain actual likenesses in some of Kelly's works, which, though issuing from other sources and another aesthetic logic, indicate that both Mondrian and Brancusi were essential to the training of his eye.

Kelly could not really talk to the seventy-four-year-old sculptor that day, since the session was mainly devoted to Brancusi's efforts to get one of the college girls present to sit on his lap. Kelly remembers, however, the extraordinary experience of moving among great sculptures that he had known only from photographs and of the effect of the lame old man with his parted beard, his pointed cap, and his white duck pajamas.

Sometime in the winter of 1949/50, in the small Galerie des Deux Iles, near his hotel, Kelly met by accident Michel Seuphor, painter, critic, and historian of de Stijl and subsequent pure-abstractionist movements. Seuphor had formed with Joaquín Torres-García the group called Cercle et Carré (1930), and had been one of the first defenders of Mondrian. He had just recently published a major work on abstract art[29] and was one of the most influential critics in Paris at this time. As a result of their conversation, Seuphor came to Kelly's hotel-studio and looked at his work, then consisting mainly of the cardboard and wood reliefs and the string pictures. A few days later, at a Hans Richter opening at the Deux Iles, Seuphor introduced Kelly to Jean (Hans) Arp (1887–1966), who in turn invited Kelly to his studio in the suburb of Meudon.

There is little question that Arp had an effect on Kelly's work and development, particularly with regard to collage and the use of chance. Prior to meeting him, Kelly had already turned his attention to collage (he even knew of Robert Motherwell's collages at this time through Coburn), and was undoubtedly familiar at least with reproductions of the duo-collages made by Arp and his wife, Sophie Taeuber-Arp, between 1915 and 1918.[30] Equally familiar, but perhaps less understood, were works

Study for *Seine: Chance Diagram of Light Reflected on Water*, 1951. Ink and pencil on paper, 4¾ x 15⅞ inches.

Seine, 1951. Oil on wood, 16½ x 45¼ inches.

Seine, a *tour de force*, is one of the most successful pictures ever made incorporating the use of "the laws of chance." While it remains true to its subject-source—reflections and shadows on water—it expands both the meaning of the subject and the minimal means by which it is achieved. Even if one had no knowledge of the title or the subject, and even though it is a totally abstract picture, *Seine* conveys a sensation of light and dark that is a true objective correlative (T. S. Eliot's term) for the artist's original sensation.

Though it is a most highly structured picture, the rational processes that went into its making are not as compelling as the vision that produced it. *Seine* is a prime example of the back-and-forth play between the selection of a subject adaptable to abstraction and an abstract method suited to the subject. The best subjects and the best pictures are those like this one, where the two dovetail exactly.

The sketches leading to *Seine* vary from realistic pencil drawings of reflections on water to stylized versions made with the squared strokes of a broad-nibbed pen (Figs. 21–26, pages 108–109). Kelly obviously searched for a rhythmical balance between light and dark, white and black, space and form—form being the shadow cast from the shape of a solid object. Or, if it is considered as a night scene, then the light thrust into the darkness is "form" and the black is the void. This second reading is less likely, however, since the light area is divided and dispersed to the sides.

Seine was a challenge to the chance method, to see if it could render images from life with some verity. Chance in this instance was given only the most restricted of roles, that of making decisions only after all the really important decisions had been made. One of the latter would seem to have issued from an old school problem assigned in nearly all design classes: ". . . take a rectangle of a certain size and make something visually interesting using fifty percent black and fifty percent white."

The idea of employing a grid was perhaps as much suggested by the results of trying to catch the flickering reflections with the square-ended pen as it may have been, for example, by Mondrian's 1917 grid compositions or his late (1942–1943) *Broadway Boogie Woogie*. In any case, to insure a "fifty percent" solution, the best way to go about it would be to have an exact way to measure the areas devoted to black and to white. In addition, a grid would allow placement to be taken over by some numerical system. But what system?

Study for *Seine: Chance Diagram of Light Reflected on Water* (1951) was made some months after the sketches drawn directly from the waterside. A grid of little rectangles was laid out on paper, forty-one units high by eighty-two long. The shape of the overall graph is an elongated horizontal, somewhat similar in proportion to what the French call a *marine* (to differentiate it from the fat, vertical *figure* and the squarish rectangle called a *paysage*). Forty-one numbered slips of paper were put into a box and mixed up. Then, starting with the second vertical row, having left the first row blank, a number was drawn and its corresponding space filled in, and the number put back into the box. For the next row two numbers were drawn, filled in, and returned; the next, three, and so on. When the center was reached and all forty-one rectangles were blackened, the operation was reversed. Obviously coagulation at the center was foreseen, as was symmetry. The system assured (1) equal areas of black

(*continued on page 32*)

such as *Collage with Squares Arranged According to the Law of Chance*, 1916–1917 (which had been on view in The Museum of Modern Art in New York since the late 1930s), and others using the same chance approach. Actual contact with the artist in Meudon may have stimulated Kelly to revaluate the possibilities of a procedure which, like automatic drawing, could banish the compositional congestion induced by academic training.

Besides the fact that Kelly would soon try the use of "the laws of chance" to solve compositional problems, there seems to have been a subtler and more important result, one affecting how and what he saw. Most of us see nature and objects, compositionally at least, as we are trained by art to see them. Thus, if torn or found pieces of paper are allowed to exhibit *au naturel* their accidental shapes, and are permitted to fall or otherwise decide their own placement on a surface, as was Arp's practice, then it follows that the accidental way nature lets things fall is complementary to this kind of art. The trick was to see things and the relationships between them before they organized themselves into conventional "pictures." Kelly had already in a sense thrown out relational composition by concentrating on the singular presence of an object. He had made such paintings as *Window, Museum of Modern Art, Paris,* 1949 (page 23) and *Saint-Louis, II,* 1950 (page 25), wherein he had re-presented physical realities more or less as they appeared. He now began to see that it was possible to abstract the accidental aspects of objects and present these instead. The approach was still literal, in the sense that the shadow of a thing is as real and objective as the thing itself and can be presented as such even without its cause. By shifting one's attention away from the cause one could concentrate on the result, such as a shadow shape, the rectangles formed by a paned window, or the space created between several objects by their accidental juxtaposition.

All these phenomena, for the most part fleeting or impermanent, appear to the eye only by chance because we normally and necessarily organize the world hierarchically and intellectually, forcing it into rational compositions even before we have *seen* it. We reject the dumb look that first and instantaneously occurs. The artist usually practices the dumb look in order to analyze, but ordinarily he too succumbs to normal habit, placing the emphasis on rational effect rather than on dumb fact.

and white, (2) an overall, principled organization, and (3) minimum subjectivity in the manner of execution. When the drawing plan was copied exactly in black and white paint on board, the actual technique was as impersonal as a house painter's, characteristic of Kelly's work since 1950.

There are similarities between *Seine* and Mondrian's *Pier and Ocean,* 1914 (Fig. 27, page 109), painted at a time when Mondrian was working his way out of pointillist impressionism. His approach, however, was symbolic. Kelly has, on the contrary, sought the equivalence of impressionist sensation in an entirely objective way, cooled by both the use of chance and by the rigid structure of the grid. His work, strangely enough, ends up as more realistic and true to the visual source than Mondrian's.

Spectrum Colors Arranged by Chance, 1952–1953. Oil on wood, 60 x 60 inches.

Spectrum Colors Arranged by Chance is a testament to Kelly's seriousness and patience in his search for knowledge about art. It is composed of 1,444 squares of color, painstakingly laid in a grid, and based on a 1951 collage of colored papers equally painstakingly made. It is only one of several such laborious studies made in an effort to discover the effective principles that underlie abstract art. His turning away from imposed "composition" and drawing at this time was essential to an exploration of the limits of color and how it functions.

Spectrum Colors is related to *Seine.* In the latter he had confined himself to black and white and had succeeded by a calculated method in achieving a peculiar and relevant painting halfway between realism and pure abstraction. *Seine,* of course, had begun with an observation from nature. The grid pictures such as *Spectrum Colors* are abstract in origin, or at least are only distantly related to sensations produced by natural sources.

A more or less chance method was used as before; basically, the picture is a slightly structured but random assortment of spectral colors. Kelly made similar studies using white as the field color. In these efforts he exhausted the methodical approach and wisely turned back to structures that had more meaning for him, such as fenestration and panel pictures, weighted by his own taste and choices.

The idea of understanding the world in terms of chance, the way things "fall" and the way we look, with our heads bobbing all the time, shifting the angle of vision, does not account for the particular selections from it that Kelly made and makes. This method of seeing *does* imply that one would need only the average cluttered living room or landscape to find enough subjects for a lifetime of painting. Kelly of course selects only situations that attract him, primarily those involving distinct qualities of shape. Exceptions to this occur between *Seine,* 1951 (page 31) and its drawings[31] and the painting of *Spectrum Colors Arranged by Chance,* 1952–1953 (opposite), when, paradoxically, he often applied chance methods literally. When he began to let his eye pick out subject matter as it by "chance" appeared to him, the predilection for shape was, nevertheless, consistent with all his former preoccupations, such as the *mandorla* on a medieval church façade, the religious figures crowded into a pendentive, the flat and contoured garments in a Byzantine icon, and even Audubon's shapely cutout birds.

In the summer of 1950 he was introduced to Youngerman's father-in-law, Henri Seyrig, an archaeologist from Beirut, and was later invited by Mme Seyrig to the family villa, La Combe, near the little town of Meschers on the river Gironde, which is really a wide bay. He returned to Meschers the following year; the two summers he spent there were, he says, among the most productive periods of his life. He made thirty or forty collages there and any number of drawings, many of them later converted into paintings. (The dates of his paintings are usually a minimum of one year—sometimes five or six years—later than that of the preliminary sketches or collages.) He drew everything—except people and landscapes. He drew the shadows cast on the wall by his balcony, and on a staircase by a railing; he drew the patterns on the striped canvas of the cabanas on the beach, the tree branches against the sky, and the twisted and rusting reinforcing rods exposed by the wartime shelling of German bunkers along the coast.[32] Some of these were done with the automatic drawing method. And he made brush-and-ink drawings purposely to cut up and paste on another sheet upon which he pushed the pieces around without looking at what was happening. Later he copied a few of these exactly in paint (see *November Painting,* 1950, page 36).

opposite: *La Combe, I,* 1950. Oil on canvas, 38¼ x 63¾ inches.

right: *La Combe, II,* 1950. Oil on wood folding screen, nine panels, each 39⅛ x 5⅛ inches; overall, 39⅛ x 46⅛ inches.

While Kelly was staying in France at the villa La Combe during the summer of 1950, his eye was drawn to the way the shadow of a handrail broke on the iron treads of the stairway leading down from his balcony room. His attraction to this phenomenon probably goes back to his experience of the camouflage nets woven with strips of oznaberg in random patterns to disrupt the tell-tale shadows of guns and tanks (see Appendix: *Kelly and Camouflage,* page 115). Since the railing was trussed in X-fashion, the shadows on the nine steps were very complex. As the sun's angle changed, the network of shadows also changed. Like Monet in the Haystack and Rouen Cathedral series, Kelly made sketches of his ever-changing subject several times during the day (Fig. 28, page 109). These sketches, however, do not deal with the stairway as it appeared in perspective, narrowing as it descended, but give to each step its true dimensions (in scale, of course). Thus each step becomes, in the drawings and subsequent paintings, a panel that is brought together with the others on one plane, forming a complete and regular rectangle.

La Combe, I is the first of Kelly's pictures to exhibit this kind of close-packed panel construction. Later he made a version of *La Combe* with separate panels, hinging them together like an oriental screen (at right). Over the next few years he made a number of pictures comprised of joined panels or squares. In the mid-1960s he returned to this method and has used it frequently since.

The gouache drawing *Awnings, Avenue Matignon* (page 37) of the same year clearly indicates, however, that it was not just *La Combe, I* that gave birth to the panel idea, but that fenestration systems also intrigued him.

La Combe, I points up some other characteristics of Kelly's way of seeing and working. He sees things in polarities: light and shadow, window and wall, shape against surface, color versus color; and he finds these polar situations where most of us do not bother to look. Here he has seen a shadow, not as an aspect of its cause, the object from which it issues, but as an independent shape in tension with the surface on which it occurs.

That fall, needing money, he took a job teaching classes in art at the American School in Paris. He found that teaching the well-heeled daughters and sons of diplomats and businessmen was quite different from dealing with students in a settlement house back in Boston. The latter came to class because they wanted to study art; the Paris group, because they had to. They were largely a discipline problem, and he had to go out of his way to invent exercises that were both amusing and instructive. Many of these were directly related to his own concerns, and so closely did some of the work touch upon the core of the problems that he saved the results for reference. One young lady, Elizabeth Huffer, gave such an inventive solution to a set problem that he reproduced a painting from it and called it *Collaboration with a Twelve-year-old Girl*. Other lessons were rather classic. One, for example, involved dribbled and spattered watercolors on absorbent paper and was intended to make the students aware of how materials work, how they could be manipulated and coordinated into effective images. Some of the soak-stain experiments call to mind the later paintings of Morris Louis; of course most of the work, like these and the cut-paper projects, had been common practice in children's art classes for fifty years. The leftovers from these projects often provided Kelly with *objets trouvés* from which he made collages. One of them, *Children's Leftovers Arranged by Chance*, 1950,[33] comprises a prophetic vocabulary of shapes that would appear in many contexts in his work in the 1950s and 1960s. One thing is curious about what is now left from these classes: the free use of color in papers and in paints is evident in the materials he supplied his protégés; yet, in his own work, color in such variety does not manifest itself until more than a year later. He had painted both in Boston and in these first three years in Paris primarily in subdued tones of brown, green, and gray, all related to the approved colors used in the camouflage corps; Kelly used them, however, to *express* volume rather than to eliminate it. The pure white of the cutouts and reliefs of early 1950 was a breakthrough into brilliance. Along with white, he began that year to use one other color, either bright blue, as in the gouache drawing *Awnings, Avenue Matignon* (at right) and *Relief with Blue* (page 27), or bright red, as in the first version of *La Combe* (page 34). Green, black, and red, in clear hues, appear together in

opposite: *November Painting,* 1950. Oil on wood, 25½ x 34 inches.

November Painting is the first in which Kelly used Arp's chance method of composition. (He had already made some collages in this fashion.) A gessoed wood panel, prepared sometime before, happened to be handy when he was tearing up an unsatisfactory wash drawing. He scattered the torn pieces over the panel to see how they would fall and liked what he saw. He held each one in place, traced its outline, and then copied the bits of image from the drawing in paint. The title came about not only because the painting was made in November, but also because it reminded him of the way the leaves in Paris were blowing and falling through space.

This turned out to be a seminal picture, full of retrievable shapes and images. In New York in the late 1950s, many of these shapes inspired other paintings and drawings.

above: *Awnings, Avenue Matignon,* 1950. Pencil and gouache on paper, 5¼ x 8¼ inches.

This little gouache drawing is, like a number of other works from 1949–1952, based on the observation of Parisian windows. Kelly has noted here the sensuous variables possible in a mundane situation, providing a pleasing rhythm through the differing divisions of the rectangle. He uses two colors, blue and white, the blue descending from the tops of the "windows." The spaces between the odd number of elements are exactly one and one-half times the width of the rectangles. Whether or not they were actually observed in the architecture or devised, they bear a comfortable proportional relation familiar to us in Greek columniation. The original drawing shows erasures shortening the lengths of the window rectangles, indicating a precise but intuitive decision and a desire to render exactly the essence of a remembered visual sensation clarified by abstraction.

Awnings, Avenue Matignon is a forerunner of the later panel pictures, and it points up the very specific sensations obtainable through careful, though non-Euclidean, divisions of rectangles into two-color areas. (Turn it on its side.)

Cité, 1951. Oil on wood, 20 joined panels; overall, 56½ x 70½ inches.

In the spring of 1951, while he was still teaching children's classes at the American School in Paris, Kelly stayed overnight with a friend at the Cité Universitaire. The Cité is a large complex of buildings, including dormitories, where many students attending various units of the University of Paris live. During the night he had a dream in which he saw all of his pupils up on a scaffold painting stripes, similar to an assignment he had given them. At breakfast in a café, he drew a sketch of what he had seen in his dream on the back of the coffee bill.

At Meschers that summer, recalling the orderly but random effect of the dream picture, he painted a number of black stripes freehand on a sheet of white paper. Ruled into squares, this was cut up into twenty panels and arranged into a collage. This he copied almost exactly on wood panels. Standing on his balcony at the villa La Combe, he had Alain Naudé rearrange the squares on the grass below, trying out different combinations and orientations. In the end he went back to the arrangement of his first collage and built the panels into a single unit.

The vertical sections, comprising four panels, tend to distinguish themselves from each other because of the disruption of the horizontal stripes. They even have a tendency to appear on different planes, grouping themselves into two forward and three back, or vice versa. This is perhaps one of the pictures that more obviously reflects the effects of his camouflage training in the Army (see Appendix: *Kelly and Camouflage,* page 115).

In *Cité,* though the black stripes were painted simply as abstract pattern, the basic idea was derived from shadows on a surface, disrupted as in *La Combe, I. Cité,* by breaking into verticals, recalls the earlier picture, and at the same time predicts many other vertical paintings composed of horizontal units. The grid construction seems to have been more of a necessity for the elementalization of the field than a compositional end in itself.

The slightly optical effect of *Cité* may remind us of the much later works of Victor Vasarely, but where the Hungarian almost always energizes his gridded field by creating a sudden shift of direction—a point or area of interest—Kelly's sensibility follows the American preference for blunt statement and an overall, consistent rhythm, as in the grid pictures of Agnes Martin and Sol LeWitt. It is notable that even in Paul Klee's *Variations,* 1927 (Fig. 32, page 110), which Kelly undoubtedly knew, there is the same European need to supply a focused visual interest; that is, a content quite separable from the overall form.

some of the collages from that summer but not in the paintings.

In the spring of 1951, just before his twenty-eighth birthday, Kelly got his first chance to show his work to the public in a one-man exhibition at the Galerie Arnaud. The gallery, later characterized in the *Arts Yearbook* of 1959 as "one of the best Parisian galleries specializing in abstract painting," showing "young painters of many different nationalities,"[34] was then an adventurous little enterprise occupying rather scrubby quarters.[35] Perhaps because of this one-man show he was included in an article about young American artists in Paris in a special issue of *Art d'Aujourd'hui* devoted to recent art in the United States (one of the paintings on the cover was a Jackson Pollock). The author, Julien Alvard, prefaced his very short critique of the seven young Americans he had chosen to cite with a lengthy apology for Paris.[36] The discouraged, existentialist mood of the piece, however, probably had no effect on Kelly, who was just beginning to work with greater confidence. Indeed, later in the year, in October, Louis Clayeaux, director of the Galerie Maeght, selected four paintings of 1951, *Meschers* (page 41), *Cité* (opposite), *Green and White,* and *Yellow and White,* for his annual "Tendance" exhibition in the rue de Téhéran. It was reported to Kelly that Georges Braque, who was regularly shown at the gallery, admired *Meschers,* finding that Kelly had solved a problem he was working on in a painting in progress (*La Bicyclette,* 1952). This recognition by the famous artist considerably strengthened Kelly's position in the gallery.

Meanwhile, the exhibition at the Galerie Arnaud had another effect. Kelly's tenure as a teacher at the American School, where some of his students had criticized him because he always wore the same (his only) suit, was ended by this exposure as an avant-garde artist. The only distress he suffered was in the pocketbook, but another invitation to La Combe near Meschers helped out for a time.

At Meschers he was able to complete some paintings from the hundreds of notes he had put down in the sketchbooks over the winter. *Cité* (opposite)[37] was accomplished this summer, as well as more collages and drawings. Back in Paris in the early fall, with money still a problem, he applied for a job with the United States government's Marshall Plan program. He got one, after an F.B.I. investi-

Meschers, 1951. Oil on canvas, 59 x 59 inches.

It is clear that *Meschers* was devised in somewhat the same way as its predecessor, *Cité* (page 39). This picture, however, is not composed of wooden squares but is painted on a single stretched canvas. Since it is square, the implications are that it was based on an original drawing, divided into a grid of twenty-five equal segments, then cut along the grid lines and rearranged, the resultant scheme being copied more or less exactly.

On the higher ground along the wide river Gironde near Meschers, France, as Kelly looked through the pine trees there was often nothing more to see than the green of the pine needles and the blue of the sky and water. Like an Impressionist, but without having to rationalize his sensation of color filled with light by attaching it to a recognizable landscape image, Kelly repossessed the abstract qualities of the scene. There is even a sense of flickering, of the branches moving in the breeze.

Unlike *Cité,* where the black "shadows" appear as if cast from a rigid grill or screen, *Meschers*'s shapes are nearly organic; enough irregular curves are included to assure this. And just above center, significantly placed where the eye will not find it a compositional conceit, is a pointed leaflike shape, which provides a clue to the painting's origins.

Again there is a vertical, paneled organization, with the second and fourth sections admitting more blue than is permitted the other three. It seems possible that Kelly was somewhat influenced (or encouraged) by Matisse's long and slender groups of colored glass windows in the nave of his Chapel of the Rosary in Vence. *Meschers* could certainly have been translated into similar glass windows. The mock-ups and designs for Matisse's Chapel had been exhibited in Paris at the Maison de la Pensée Française (ironically, as Alfred H. Barr, Jr., describes it in *Matisse, His Art and His Public,* 1951, p. 281, a kind of "Communist culture center") from July to September the previous year (1950). The Chapel itself, however, was not opened until June 25, 1951, just about the time Kelly was working on *Meschers.* But without being specific about a relation to the Vence Chapel as such, one can see that Matisse's messages about shape and color were never lost on Kelly.

Indeed, Matisse himself wrote in his short essay on the Chapel: ". . . simple colors can act upon the inner feelings with all the more force because they are simple. A blue, for instance, accompanied by the shimmer of its complementaries, acts upon the feelings like a sharp blow on a gong. The same with red and yellow; and the artist must be able to sound them when he needs to" (Barr, p. 288). Kelly has shown over and over again that he can ring that gong, even without the "complementaries" and in black and white as well.

gation that reached all the way back to New Jersey and Boston. He was employed as a security guard. Since it was night work, he had the days for painting. A bit of luck, however, delivered him from such work after a couple of months. A Swiss textile manufacturer and art collector, Gustav Zumsteg, had seen *Meschers* at the Galerie Maeght and invited Kelly to submit some designs for translation into fabrics. Seeing an opportunity to earn his way through his art rather than by guard duty, he accepted; in late November, with a little cash in his pocket, he was able to return to Sanary with Ralph Coburn.

In Sanary that winter and spring Kelly could count on the company of several good friends. Anne Child Cajori (later Anne Weber), a former classmate at the Museum School, had come to France from Boston a few months earlier and now had a studio in Sanary. Alain Naudé, a South African who was in the process of shifting his career from music to art, and whom Kelly had befriended earlier that year, also came down to the edge of the Mediterranean. Each found a studio-living arrangement near the sea.

Kelly's move to Sanary and the light-ridden Riviera had an immediate and lasting effect on his art. One is reminded of van Gogh's progress when he moved from the north to the south, of how the dark and heavy painting he produced in the gloomy atmosphere of the Borinage, a mining district in Belgium, grew lighter and more colorful in the silvery air of Paris and then burst into full radiance in Provence. Kelly's work in Sanary, on the edge of a light-reflecting bay full of fishing boats, contrasted sharply with works from overcast Paris in December. Almost immediately Kelly began to think as well as work in terms of color. The notebooks suddenly burgeoned with designs for paintings, with the names of a great variety of hues written in. Many of these notations on the sketches also identified instances where physically separate panels were to be joined, a practice he had begun with *Cité;* he was now to extend it by painting each such tile in its own color. The sharpness of the chunks of color may well have been suggested by similar chunks of color afforded by the typical Mediterranean village of Sanary, where, if the buildings are not painted in bright hues, the doors and window shutters are, and the whiteness of the general landscape stands out.

above: *Kite, II,* 1952. Oil on canvas, 11 joined panels; overall, 31½ inches x 9 feet 2 inches.

below: *Painting for a White Wall,* 1952. Oil on canvas, five joined panels; overall, 23½ x 71½ inches.

opposite: *Red Yellow Blue White,* 1952. Dyed cotton, 25 panels, each 12 x 12 inches; overall, including space between sections, 60 inches x 12 feet 4 inches.

Kite, II and *Painting for a White Wall* are pictures that Kelly quite obviously drew on for his panel groups in the late 1960s. *Kite, II* has close affinities with *Awnings, Avenue Matignon* (page 37). It repeats the periodic rhythm of fenestration, while abandoning the counterrhythm found in the unequal divisions of the dark and light areas. As in *Sanary* (page 53), he has used an odd number of vertical sections, exchanging dark for light. In *Red Yellow Blue White,* 1952, he actually separated the panels in space. The latter picture is made of dyed cotton rather than oil on canvas.

The colors, besides black and white, in *Kite, II,* are the primaries plus green. In *Painting for a White Wall* the selection is far more arbitrary. He keeps the pale orange and pink and white from tapering off into the wall by enclosing them between a purplish blue and a bright, strong blue. This painting has a lyricism and openness unusual in his work.

Kelly had given up painting the human figure and had put his plant and nature drawing into a separate category, and so he began again to pursue his fascination with architecture. His association of the flat façade with the flatness of the canvas, his sketches of walls articulated by chimneys and shadows, and his subtle use of architectural fenestration to devise acceptable rhythms and spacing lie behind much of his abstract work between 1950 and 1953. From his representation of the *Window, Museum of Modern Art, Paris* (page 23)[38] to the Kite pictures of late 1952 (see *Kite, II,* page 42) and even up to the panel pictures of the 1970s, his preoccupation with these architectural sources is evident.

It is not surprising then to learn that Kelly took a trip to Marseilles just to see Le Corbusier's apartment house, Habitation, while it was still under construction. He had already studied the architect's Swiss Pavilion at the Cité Universitaire in Paris and had even used one of what Peter Blake called the "viewing slots" in the parapet wall atop the slab as an idea for a painting.[39] Unquestionably Corbu's punctured fenestration and his regular but articulated panels on the end walls had an influence on Kelly. Habitation, which he managed to climb around, offered something more—a use of color in modern building Kelly had not seen before. The walls between the balconies were painted bright pastel shades. Corbu was obviously using color to connect his new building form with local tradition. But for Kelly it was something of a shock. He felt that in some way Corbu's scheme diminished his own painting.

Despite Kelly's debts to Le Corbusier and perhaps owing to his continued shyness and modesty, he never made an effort to meet the master architect. But his friend Naudé, who had a slight connection with Corbu, showed him slides of some of Kelly's paintings along with his own and returned with a message that the master had said: "Young people have it so easy these days." Evidently Le Corbusier was thinking of his own early difficulties and what his legacy had cost him. Le Corbusier also observed: "This kind of painting needs the new architecture to go with it."

A tiny sketch in the Sanary-period notebooks ties Kelly's involvement with architecture, particularly fenestration and the organization of panels of color, into a much earlier experience. Upon arriving in France he had gone to Colmar to see the Isenheim

Colors for a Large Wall, 1951. Oil on canvas, 64 joined panels; overall, 8 x 8 feet. The Museum of Modern Art, New York. Gift of the artist.

This picture is one of the largest Kelly made in France. The organization, aside from its square panels joined in a grid, is totally arbitrary; the juxtaposition of colors was a matter only of taste. It began, as was Kelly's custom at this time, with the creation of a collage. Using the exact number of leftover squares of colored paper from which the collages for the series of Spectrum Colors Arranged by Chance had been composed, he made the study for *Colors for a Large Wall* and that for *Sanary* (Waldman, plates 60 and 61). The hues of the colored papers, bought in art stores, were precisely matched in oil paints, and the final, full-sized panels arranged in strict adherence to the paper model.

Altarpiece, which exhibits the opening-and-closing construction of most such classic altarpieces. Opened, it is a revelation, not only of the mystery, but of radiance. Kelly recalls vividly the brilliance of Grünewald's golden light. Closed, it presents the Crucifixion largely in dark and light, chiaroscuro. Kelly's little sketch, unfortunately never executed, shows a long horizontal rectangle composed of four square panels, blue and red in the outer squares, and two different yellows in the middle panels.[40] The companion drawing shows that the two outer panels are hinged and when closed upon the center pair would have been painted black (left) and white (right). While it is logical to assume that, with his passion for windows and doors, the ubiquitous shutters and gates of France are related to this proposed painting, the connections to the Isenheim Altarpiece, not only in terms of carpentry but also in terms of the concept of revelation, are too strong to be ignored.

Indeed, there are many drawings of metal shutters from Sanary's thick-walled, plastically constructed buildings. The reveals of such Mediterranean-style architecture are deep and often without the framing edges so absolute and necessary in the wood clapboard construction of North America or the freestone building in the less "plastic" styles of Northern Europe. The clear face of a building wall anywhere around the Mediterranean basin provides a surface which, if the orthogonal shadows of the reveals and doorways are ignored or the openings are seen simply as rectangular patterns on a two-dimensional plane, becomes a perfect subject-source for an artist like Kelly. Later he might, as he has done, translate the reveal along with its deep shadow into a flat pattern or reconstitute it in a sculptural expression; but during these early years he had to understand it in terms of the rectangle, the shape of the conventional easel picture. Thus paintings and collages from 1952 and 1953 that seemingly stem from Neo-Plasticism or de Stijl actually derive from architectural sources predating twentieth-century "geometric idealism" by hundreds if not thousands of years. At the same time it is clear that he was drawn not to the plastic qualities of this stucco and concrete architecture but to its surfaces, its flat façades and silhouettes into which rectangles were cut.

It is obvious that Kelly was looking for substitutes for drawing and brushwork from the time he made the wood and cardboard reliefs. The standard collage method was another way. And though he had used the chance system in making collages, the results were not what he was aiming at, since he was still deeply committed to reproducing the sensations he experienced before objective subject matter. The idealism implied in pushing things around to make pleasing arrangements, unrelated to the real world, was not in his nature or in his American heritage. A subject observed and represented, whether it be a garden gate or light reflected on the Seine, was a guarantee of the kind of validity his congenital pragmatism demanded— Antaeus on tiptoe perhaps, but still Antaeus. Despite his growing admiration for Mondrian, and even the occasional similarity of some of his own work to that of the Dutch master, he could never give himself over to speculation in pure form. Even such a painting as *Colors for a Large Wall* (page 44), so reminiscent of some of Mondrian's first steps toward pure abstraction (for example, *Composition, Checkerboard, Bright Colors,* 1919),[41] was still a subjective response, as his friend Anne Weber said, "to the bright light and color of Sanary." Certainly Kelly wanted a means to keep his work "cool," or he would not have needed to give up brushwork and its personal mannerisms; he sought a means that would put some distance between the work and the subject and between himself and the work. And for a while he gave himself over to pure process, as in *Spectrum Colors Arranged by Chance* (page 33) and its companion color studies. But always in the back of his mind, as recorded in the sketchbooks, is the real world with its patterns and shadows, its objects and their shapes.[42] And when the real world begins to disappear in the abstraction of the design, it is analogized in the physicality of the individual panels presented as separate, factual objects.

Each one of the sojourns away from Paris— Belle-Ile, Meschers, and Sanary—had brought about major but logical changes in Kelly's art. When he left Sanary in May 1952 (at the end of the cheap-rent season), a period of consolidation was about to begin. Since money was short again, he joined Naudé, who was enjoying a rent-free summer in a villa in Torcy, east of Paris near the river Marne. In October Clayeaux included him once again in a "Tendance" show at the Galerie Maeght. The other painters were Debré, Degottex, Naudé (Kelly's friend), and Palazuelo. Kelly exhib-

ited three pictures: *Colors for a Large Wall,* 1951, *Méditerranée,* 1952, and *Sanary,* 1952 (the last two under other titles; see right and page 53).

In September he had gone with Alain Naudé to Monet's former home in Giverny, some 45 miles northwest of Paris. Kelly was thoroughly familiar with Monet's painting of the 1880s and 1890s; the Boston Museum owned over thirty pictures of that vintage. Although he had seen some of the large *Nymphéas* (Water Lilies) at an exhibition in the Kunsthaus, Zürich, before going to Torcy in May, he had not seen the Clemenceau installation in the Orangerie in Paris at this time. This last is not as peculiar as it might sound. Monet's reputation was at a low ebb in Paris, since his work appeared to be structureless in the Cubist and post-Cubist climate. In fact the real revival of Monet, based largely on the *Nymphéas,* was brought about by American Abstract Expressionism and subsequent developments in color-field painting.

Kelly and Naudé were shocked by the condition of the studio at Giverny. Windows blown out during the war had not been replaced; huge paintings from the 1920s were carelessly stacked and in some cases had been rained upon.[43] But the experience of these works, especially in juxtaposition to the gardens where they were painted, the evident ambition of the old man, and their size and scale, had a lasting effect on Kelly; though their influence did not occur, perhaps, until his own large Spectrums and separated panel pictures of the 1960s.

After four years of almost continuous development, the period between the spring of 1953 and early summer of 1954 seems to have been one primarily devoted to executing ideas laid out in the sketchbooks. There also seems to have been a growing feeling that Europe had little more to contribute to his vision. The only recognition he was granted in 1953 was the inclusion of one picture in a group show at the Museo de Arte Contemporáneo in Santander, Spain. At Christmas time he went to Holland with Geertjan Visser, a young Dutchman he had met in Zürich, who took him to see Solomon Slijper's Mondrian collection. It was Visser's family, living in Papendrecht near Rotterdam, who later took him in to recuperate after a five-week hospitalization for jaundice in Paris the following spring. Being too weak to go out or to do anything very strenuous, he had his nurse bring him materials to make collages. Dutch

Méditerranée, 1952
Oil on wood, nine joined panels;
overall, 59¼ inches x 6 feet 4¼ inches

Tiger, 1953
Oil on canvas, five joined panels; overall, 6 feet 9 inches x 7 feet 1½ inches

colored paper was more brilliant and darker in hue
than French, and these collages suggested a whole
new range of values. Still tired from his illness and
suffering the "jaundice depression," he returned to
Paris and put his things together for the trip home.
After nearly six years abroad, he boarded the *Queen
Mary* for New York in July 1954.

NEW YORK: 1954–1960

KELLY'S DECISION to return to America came about
partly because he had picked up a copy of the
December 1953 *Art News* magazine in a bookstore
on the rue de Rivoli. It contained a review of a
recent Ad Reinhardt exhibition at the Betty Par-
sons Gallery. The paintings reproduced made him
think that his own work might be welcome there.
Since the Cunard Line was the only steamship
company that would transport his pictures on
credit and he had only enough money for passage,
he sailed on the *Queen Mary*.

Thirty-one years old, Kelly had spent six years
away from the States. He knew only one artist
(Fred Mitchell) in New York. He found the art
world there "very tough" compared to Paris and
doing things "he did not understand"; by this he
meant in particular the younger generation of
painters who were involved in action painting, fol-
lowing, on the surface at least, Jackson Pollock,
Willem de Kooning, and Hans Hofmann. Against
this background of splash, drip, and stain, his own
painting seemed (and was seen as) out of sorts if
not out of date. He had felt somewhat the same
when he first went to Paris, but then he had viewed
himself as a student. Now a full-fledged artist, he
was something of a foreigner in his own country.

Five years before this he had met John Cage, the
avant-garde composer, who had stopped at the
Hôtel Bourgogne for a short time. Cage had come
to see his paintings, and over the years they had
occasionally corresponded. Kelly had sent him a
contact sheet of photos of some of his paintings.[44]
In his letters Cage had mentioned an "interesting
young painter" he knew—Robert Rauschenberg.
Upon arriving in New York, Kelly looked him up.
Rauschenberg was then engaged with his early
"combines," paintings that collaged together every-
thing from bedspreads and comic strips to stuffed
birds and goats. This kind of art outstripped even

Kelly in his New York studio, 1957

White Plaque: Bridge Arch and Reflection, 1952–1955. Oil on wood, 64 x 48 inches. Private collection, London.

White Plaque: Bridge Arch and Reflection is full of implications, iconographical and formal. The Pont de La Tournelle in Paris spans the Seine from the Quai de La Tournelle to the Ile Saint-Louis (Fig. 42, page 112), not far from where Kelly had his hotel-studio. The original bridge was constructed in the fourteenth century, but it has been rebuilt a number of times. Now there is a broad central arch, but along the quai-side there is a kind of tunnel-span that gave rise to *White Plaque.* In a peculiar light one day Kelly noticed that the latter arch formed a black shape and that its reflection on the water was also black. He held the vision in his head and upon returning home cut out the total image, shadow plus shadow, from dark paper (Waldman, plate 55). In the winter of 1954/55, after his return to New York, he made a full-sized version in wood. This version is pure white because Kelly liked the way it looked after he had covered it with a coat of gesso.

Actually *White Plaque*'s shape derives from two non-things: the hole under the bridge and the reflection of the hole on the water. If one can legitimately speak of the planes of non-things, it is clear that Kelly took two images whose apparent planes were at right angles to each other and flattened them into a single surface. (He does just the reverse in his sculpture of the 1960s.)

In the collage he used a darker piece of paper for the horizontal division between the mirrored halves to provide an optical equivalent of the darker area immediately under the bridge. In the white version he accomplished this effect with a clearly differentiated strip of wood, translating it into an actual shadow—a rather appropriate solution

for this problem. Visually it operates like the revetted lines in *Saint-Louis II,* where the same type of simulation of fact was employed (page 25). It would seem that in the *White Plaque* he used considerable license in converting black shadow into white light (or at least its white-paint equivalent), but the decision to paint the entire surface white was made in terms of the work of art as such, and not in terms of its likeness to its subject. Yet, paradoxically, since light and shadow are Siamese twins within the same phenomenon, each exists as a paradigm of the other. On a dark day, or at night, for example, the bridge and the atmosphere could have been drowned in darkness, and the same double image could have appeared as lighted areas of shape. The emphasis was thus placed on shape, as such, without belying its primary source. That source was only a fragment of the environment, a chunk of reality taken out of the usual context in which it is viewed. Without a title and an explanation we would be unable to divine its origin. But the insistence of Kelly's shapes, and the obvious integrity in the drawing and the workmanship, push mere curiosity aside and instill confidence in the work for its own qualities.

White Plaque was a very early forerunner of what later came to be known as the shaped canvas. Though Kelly's *Window, V,* 1950, has often been cited as the first such instance, the latter, equally true to its source (the shadows of telephone wires on a wall, made by light streaming through an odd-shaped window), is nevertheless more arbitrary pictorially in the final piece. The linear elements in *Window, V* are contradistinctive to the external shape. In *White Plaque* the purity of the field of white and the billowing, symmetrical radiation from the horizontal axis find a perfectly logical and sensuous completion at the perimeter.

Sanary, 1952. Oil on wood, 51½ x 60 inches.

Like other pictures produced or designed in Sanary during the winter of 1951/52, this one began as a collage (Waldman, plate 61) made of chips of colored papers. Like *Colors for a Large Wall* (page 44), its color arrangement is arbitrary, except that the darker hues are placed in three vertical rows separated by rows of lighter colors. Unintentionally, perhaps, owing to the close values of colors here and there, a slight plaid effect occurs, weaving a few strips of the image in and out like chair-caning. The horizontal orientation, of course, differs from other pictures and color studies made at this time.

the wildest of French *tachisme* and *art informel.* Kelly felt even more lonely after this encounter, but he did not back away from his own kind of art. (Five years later Dorothy Miller, in her "Sixteen Americans" show at The Museum of Modern Art, included both of them, along with Frank Stella, Jack Youngerman, Jasper Johns, and Alfred Leslie.)[45]

Kelly found a studio at 109 Broad Street, at the southern end of Manhattan. Around the corner on State Street was the Seamen's Church Institute where, passing for a sailor in his dungarees, he was able to eat for virtually nothing. To support himself he got a night job in the Post Office.

During his last year in Paris he had turned to black and white more frequently. Whether or not this was related to his illness and its concomitant depression is hard to say. The last pictures in color, such as *Colors for a Large Wall,* 1951 (page 44), *Painting for a White Wall,* 1952 (page 42), and *Tiger,* 1953 (page 48), evidence a drift away from primary sources. In retrospect, it is clear that whenever such a drift carried him too far toward the realm of pure abstraction, he made an effort to reestablish connections with the world around him through subject matter. Sometimes these connections were maintained outside painting—by such means as the plant drawings (pages 96–97)—but sooner or later his painting seemed to require a more direct relation to literal visual experience. At the same time, there was a need to simplify, to get back to two colors and single images. The sequence seems to follow a consistent pattern: white with black; then white with one other color; and eventually two or more colors without white.

The violence done to his psyche by New York nearly paralyzed him at first. Most of the pictures executed in the first year were projects planned or begun abroad, some from drawings made two years or more before. *White Plaque: Bridge Arch and Reflection,* 1952–1955 (page 51), was finished the first winter on Broad Street from a collage of 1951.[46] New sketches and collages slowly emerged but they were based not on the more recent color panels like those of *Sanary* but on visual experiences similar to those of his first years in Paris. He was seeing specific "things" again; a loose wire hanging curvaceously against a wall, the reflection of his window on another window across the street (see *42nd,* 1958, page 54), the changing shadows on his book while reading in the bus (see *Atlantic,* 1956, page 56),

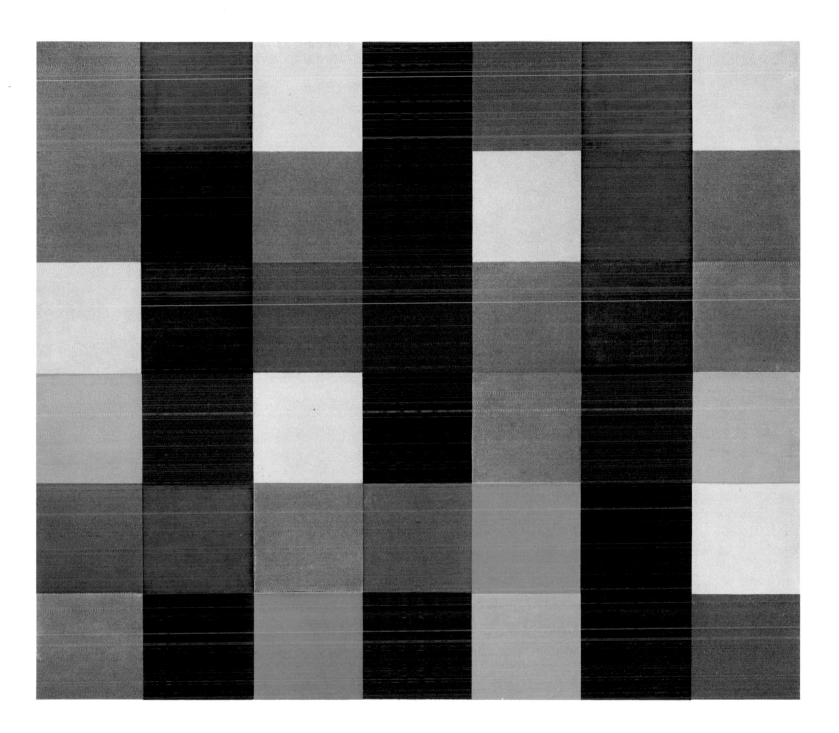

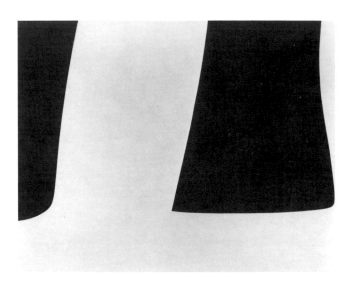

above: *42nd,* 1958. Oil on canvas, 60½ inches x 6 feet 8 inches. Galerie Maeght, Paris.

opposite: *Red Blue Green,* 1963. Oil on canvas, 7 feet x 11 feet 4 inches. Collection Mr. and Mrs. Robert Rowan, California.

Five years separate the painting of *42nd* and *Red Blue Green,* but the procedure Kelly followed in arriving at the ultimate images was similar and one he has often used.

In Kelly's work the window has played a major role both as a motif and as an idea. He has also found it a helpful tool for isolating an intriguing image, as in the Knickerbocker Beer sign pictures (see *Paname,* page 66). One day, looking from his studio at Coenties Slip, he noticed the shadowy reflection of his windows on another across the street. The glass in the other window was poorly made and dirty—so much so that the reflection was badly distorted. What was actually straight was reflected as curved or bent. Moving around in his room, using the shape of his window to frame portions of the scene, he made a number of sketches from different angles. One of them became *42nd.* The title refers to no place, though it would seem to derive from the street in New York. In the first couple of years in New York Kelly simply named pictures categorically in order to distinguish them from paintings done in France.

The source of *42nd,* of course, does not account for its compositional elegance, but knowing the source may help to dispel any notion that Kelly's images come from the work of other painters and may help to explain why there is always a freshness and individuality in his paintings. With Kelly the visual takes precedence over the conceptual. Although a few years later he would depend less and less on such natural sources as light, shadows, and architectural elements, his years of "drawing from the model," so to speak, would leave him with an extraordinary ability to "draw from memory." In the proportions, for example, of his works from the late 1960s and early 1970s, when his pictures had become panels of pure color, the sizes were determined not by any geometric formulas but by a taste and experience developed during the period when original sources predicated certain kinds of decisions.

Red Blue Green was painted in 1963 when he was working with a vocabulary of more arbitrarily selected shapes, less close to observed sources. This picture has affinities, however, to *Relief with Blue,* 1950 (page 27), but is hardly derived from it. *Red Blue Green* utilizes two shapes that had preoccupied him for a long time, the rectangle and the ovoid. The picture is the result of an image cropped from these two shapes by overlays on the original sketch. In two other paintings different versions were made, and the theme also appears in a suite of twenty-seven lithographs published in 1964 by Maeght Editeur in Paris (Waldman, cat. no. 6–32).

Red Blue Green is a fine example of a relatively rare type of canvas: that constructed of three colors with distinctly different-shaped areas. Kelly's forays into three or more colors have almost always been of the panel variety and are usually composed of equal-sized panels. It would seem that he has backed away from the problem expressed in *Red Blue Green* not because he cannot handle it—this picture is positive proof of that—but because he had to have a neutral, nonassociative shape as a vehicle for the colors in order not to set up competitive figurative or landscape spaces and objects. He was committed to shape first; color second. When a single shape is seen against a ground, or lies *in* that ground-space, the surface tension across the whole field is controllable. Three colors, however, imply three levels, and the whole thing is apt to drop back into the illusionistic world of foreground, middleground and distance. *Red Blue Green* very nearly does that. He has, however, so carefully adjusted the values of the colors and the sizes of his shapes, as well as the scale of the whole—seven feet high by nearly twelve long—that he avoids the illusionist trap. The green, for example, is so brilliantly present and its own shape so clearly positive, even though competing with two far simpler shapes, that it does not melt into space.

It is probable that in solving the problems of such three-color pictures, Kelly discovered the kind of color he is most known for. The clarity, brilliance, and intensity he had achieved in black and white (the touchstones for all his work) were instrumental in—indeed were indispensable to—his success in *Red Blue Green.*

opposite: *Atlantic,* 1956. Oil on canvas, two joined panels; overall, 6 feet 8 inches x 9 feet 6 inches. Whitney Museum of American Art, New York.

right: *Black and White,* 1955–1958. Oil on canvas, two joined panels; overall, 45 x 60 inches.

In the fall of 1954, shortly after returning to New York from Paris and getting settled in his new Broad Street studio, Kelly went to Staten Island to visit a friend. After the ferry-ride he took a bus. He was making an effort to read a paperback book on his lap, but black shadows from the lampposts and telephone poles kept breaking across the white pages as the bus drove on. Inspired, he took out his pencil and as fast as he could, recorded the outlines of the shadows, flipping the pages as each image disappeared. Later, at home, in a blank-page dummy for a forthcoming book by Siegfried Giedion, the Swiss architectural historian, given him by his friend, Hugo Weber, he copied the twenty or so shadow-images he had limned in the paperback. These images were filled in solid with black ink. They became a notebook of pictorial ideas.

The painting *Atlantic,* 1956, was retrieved from two facing pages in the Giedion "book." It is apparent that the pages in the paperback were not flat when the image was recorded but swelled roundly as such books do. The curves are thus not arbitrarily designed but follow a natural cause, which endows them with vitality. The tension point, too, where the two white forms meet, at what was the seam of the book, has a rightness about it that one suspects could not have resulted simply as a matter of taste.

Chance had once again provided the stimulus, but the particular recognition of the image and the concept of a shadow as concrete go back to *La Combe, I* (page 34) and to Kelly's training in camouflage (see Appendix: *Kelly and Camouflage,* page 115). Throughout Kelly's work in painting and sculpture there is a curious mixture of bending and flattening, reminiscent of Paul Feeley's aphorism: "Art is always about turning two into three or three into two." Here the ray of white, bent over the original book page, is reproduced on a flat surface; yet it retains the characteristics of its initial state, giving rise to a kind of visual speculation often encountered in Byzantine icons and Japanese prints. Illusion is both offered and denied.

The diptych associations in *Atlantic* and in *Black and White* cannot usually be shown in reproductions. The actual separation down the center between the two panels of stretched canvas is too subtle for the camera and the printing process. Nevertheless it is an affective part of the original pictures. In *Atlantic* it reduces the sense one may get in the reproduction of a perspective leading to the point where the curves meet on the central axis, because the physical presence of the edges of the canvases is too apparent. Similarly, in the other picture, derived from the same "shadow" book, the swinging back of the shape in the right-hand panel is stopped by this recognition of the physical truth.

Besides being one of the first pictures that reintroduced the curve into his work, *Atlantic* is the first of Kelly's black-and-white paintings that can be called a "night" picture. The last is defined as one wherein the white is the shape and the black is space. Most of us, probably by a habit derived from reading black print on a white page, associate form or shape with the black, seeing white as space. This is also corroborated by daytime visual experience, objects usually being darker in value than the sky. At night, when all is more or less black, it is the limning of objects by the remnants of light that makes them stand out. In Kelly's black-and-white pictures, and his two-color pictures also, there is no ambivalence. One area is always shape; the other, space, even though occasionally there is an intentional tension between them. The latter is particularly apt to confuse that spectator who is visually addicted to the black = form, white — space formula.

opposite: *Gaza*, 1952–1956. Oil on canvas, four joined panels; overall, 7 feet 6 inches x 6 feet 7 inches.

Throughout his career Kelly has tended to prefer relatively pure colors in or near the standard spectrum, but on occasion he has softened the hues and harmonized the values. Even in this type of painting, however, there is usually one color that asserts itself so strongly that it must be balanced by large areas of the weaker colors. The interaction between intensity and area is nowhere more evident than in *Gaza*.

A small amount of hot red usually dominates any situation into which it is introduced, unless it is equally balanced in every way by the other two primary colors. Red also seems to get hotter when juxtaposed with only one of the other two colors. *Gaza* proposes to confront this visual problem.

Kelly's solution is first to state the possibility of a stand-off in the top two panels, equal areas of the same value. Then, as a kind of test, he adds a wider panel of a yellow that has a little red in it. At this point the painting would develop a forward-backward orientation, with the colder yellow in the middle slipping back into space. The addition of an even larger panel of the cold yellow at the bottom is a master stroke. Since we usually think of the bottom of a picture as the foreground, everything that happens above is apt to be read as recedent. But the cold yellow at the bottom of *Gaza* plays havoc with this conventional reading. It equates itself with the aggressive red at the top, and the intermediate steps between are caught up in the contest. Ultimately all win and the picture settles down in a kind of radiative way, full of life, but acceptably apprehensible as a unified experience.

The title *Gaza* occurred to him because it was a time of war between the Israeli and the Arabs along the Gaza strip, and the blinding light of the sun and the color of blood seemed to be symbolized in the painting.

right: *Brooklyn Bridge, VII*, 1962. Oil on canvas, 7 feet 8 inches x 37½ inches. Collection Solomon Byron Smith, Lake Forest, Illinois.

Brooklyn Bridge, VII was not painted until 1962, and its title is somewhat misleading. In 1955–1956 Kelly had made numerous sketches of the bridge, which was only a few blocks from his Lower Manhattan studio. There is a certain nostalgia for Paris connected with this subject going back to the Pont de La Tournelle and the *White Plaque: Bridge Arch and Reflection,* which he had just finished in New York. He had walked over the bridge to Brooklyn many times and was especially affected by the way the light broke through the gothic openings in the end pylons (Fig. 43, page 112) and the great sweep of the curves formed by the suspension cables. He made a number of small paintings based on this theme.

But at this time, in the early 1960s, Kelly was arbitrarily titling his pictures with New York place names (*42nd, City Island, Manhattan,* et al). The titles, more often than not, had nothing to do with the real subject. Although *Brooklyn Bridge, VII* looks as if its source were the bridge, it was actually based on a drawing of a sneaker; the white piping on the dark-blue canvas at the lacings had appealed to him.

the light through the pylons of the Brooklyn Bridge.[47] The store of such material for future paintings was thus replenished.

Alexander Calder, whom he had met in France through the Seyrigs, came down to see him. Calder generously paid his rent for a month, besides writing notes about him to Alfred Barr, James Johnson Sweeney, and others. Sweeney, then Director of the Solomon R. Guggenheim Museum, came to look, and Dorothy Miller came down and borrowed *Window, Museum of Modern Art, Paris* to show to The Museum of Modern Art's acquisition committee (they did not buy it, however). In the fall of 1955 David Herbert stopped by and later advised Betty Parsons to give Kelly a show. In May of 1956 he received his first New York exhibition at her gallery.[48]

A chance meeting with Richard Kelly, the lighting designer (no relation), brought him a commission for sculptural space-dividing screens in the new Transportation Building designed by the architect Vincent G. Kling for Penn Center, Philadelphia.[49] Working with the company of Edison Price, Kelly had his first chance to develop some of his ideas in metal and in conjunction with an architectural setting. Although the screens for the restaurant area are more successful functionally, the tympanum over the lobby entrance (page 62), partly painted in solid colors, has more relation to his later work. Models were ready in September 1956, and installation of the works was completed the following February.

Meanwhile he had moved to a larger loft at 3–5 Coenties Slip, a few blocks from Broad Street, where he was to remain for seven years. In the fall of 1957 Betty Parsons gave him his second exhibition at her gallery.[50] But earlier three pictures, *Atlantic* (page 56), *Bar* (page 63), and *Painting in Three Panels* (page 64), all from 1956, had been selected for the "Young America 1957" show at the Whitney Museum of American Art. Of the thirty artists in the exhibition, Kelly stood out as unrelated to the rest. Most of the sculpture and painting that were not from the "action-painting" school were close to the Boston expressionism he had long since left behind.[51] His *Painting in Three Panels* was actually the most radical entry and was viewed by some as a joke and by others as a maneuver to get more than his share of space. The idea of several separate canvases constituting a single

Orange Red Relief, 1959. Oil on canvas, two joined panels; overall, 60 x 60 inches.

In Kelly's sketchbooks of 1951–1952 there are numerous drawings in pencil and in color of proposed pictures in which a portion of the surface was to be in higher relief than the rest. This was usually in the form of a panel. These ideas were, of course, related to the earlier string reliefs (page 24) and *Relief with Blue* (page 27), and to his whole preoccupation through the years with the physical presence of his work. *Méditerranée,* 1952 (page 47), was actually constructed with a relief panel, as were several other pictures of the period.

In 1955 Kelly made a small painting, *Yellow Relief,* in which the left-hand panel of two was an inch or so thicker than the one on the right side. The whole rectangle was painted the same yellow, and the painting's "sole articulation was the slight literal projection forward of half of the surface" (noted by William S. Rubin in *Frank Stella,* 1970, p. 118). This use of a real shadow to activate the surface subtly and change ever so minimally the color along the seam recalls *Saint-Louis, II,* 1950 (page 25), as well as the indentation in *White Plaque: Bridge Arch and Reflection,* 1952–1955 (page 51).

In *Orange Red Relief,* 1959, he has placed together two closely allied colors, as he had juxtaposed pink and orange in *Painting for a White Wall,* 1952 (page 42). The raised surface here not only accentuates their subtle difference but prevents any optical mixture that would have occurred along their common frontier had they been painted on a single canvas. This distaste for optical mixture goes to the heart of his quest for making all parts of his pictures equally "real" and devoid of uncontrollable illusions.

Another and larger version, *Blue Tablet,* is again a monochrome like the little yellow relief and was made in 1962. Shortly thereafter Kelly returned to the single-colored joined panels as his prevailing mode of procedure.

opposite above: Lobby Sculpture, 1956–1957
Anodized aluminum, 12 x 65 feet x 12 inches
Transportation Building, Penn Center, Philadelphia

opposite below: Section of brass space divider, Restaurant,
Transportation Building, Penn Center, Philadelphia

above: *Bar*, 1956
Oil on canvas, 32¾ inches x 8 feet

above: *Painting in Three Panels,* 1956
Oil on canvas in three parts:
30 x 22 inches; 34 x 22 inches; 6 feet 8 inches x 60 inches;
overall, including space between panels, 6 feet 8 inches x 11 feet 7 inches

opposite: Kelly, third from right,
with Delphine Seyrig, Robert Indiana, Duncan Youngerman, Jack Youngerman, Agnes Martin,
and Kelly's dog Orange on roof of No. 3–5 Coenties Slip, New York, 1958.
Photograph by Hans Namuth

Paname, 1957
Oil on canvas, 6 feet 5½ inches x 60 inches
Collection Richard Kelly, New York

picture was not new to his work but was new to New York in 1957.

A number of paintings and images developed from visiting his friend Robert (Clark) Indiana, whose studio was just down the block. Sitting around with Indiana, he often made sketches, some of the artist and some out of his window. Attracted as ever by the way windows frame fragments of the landscape, Kelly found that the lettering on a Knickerbocker Beer sign on a nearby wall presented any number of usable patterns. Large colorful letters appeared as fragments; their curved and angular shapes made innumerable abstract images. He exploited this phenomenon many times, and most of the "notched" pictures, where the large central figure is created by smaller acute-angle insertions from the sides, issue from it (see *Paname*, 1957, opposite, and *Yellow with Red*, 1958, right).

In 1958 things began to pick up somewhat. Gordon Washburn invited him to submit a picture to the Carnegie international exhibition, and that institution acquired *Aubade*, 1957.[52] And the Galerie Maeght in Paris, where he had shown in 1951 and 1952, offered him a one-man exhibition and published a handsome catalogue illustrated with his designs.[53] Lawrence Alloway, then Director of the I.C.A. gallery in London, saw the show and advised the British collector E. J. Power to buy; Power bought eight works.

The painter Agnes Martin had recently moved into his building on Coenties Slip. One morning when sharing coffee with her, he had bent a round can-lid and let it rock on the table. She suggested that he "make that." He had already made some sketches of sculptural ideas, mostly related to the Transportation Building sculptural mural, but this can-lid was the origin of a new set of ideas closely related to the shapes he was using in his paintings (see the 1959 sculptures *Pony,* page 68, and *Gate,* page 71).

By 1960 Kelly was an established New York artist, showing regularly and receiving growing public attention. His general direction was now clear, and he could call freely upon a rich body of work, and ideas for work, from his past—ideas he was also well prepared to extend as far as he cared to. Sources as such became less important in the formation of new directions, but the attitudes and the characteristics of his art have always been consistent even as it changes outwardly.

Yellow with Red, 1958
Oil on canvas, 6 feet 8 inches x 44½ inches

Pony, 1959
Painted aluminum, 31 inches x 6 feet 6 inches x 64 inches
Dayton's Gallery 12, Minneapolis

North River, 1959
Oil on canvas, 6 feet 6 inches x 70 inches

Rebound, 1959
Oil on canvas, 68¼ x 71½ inches
Collection D. Franklin Königsberg, Los Angeles

Gate, 1959
Painted aluminum, 67 x 63 x 17 inches
Collection Mr. and Mrs. Hall James Peterson, Petersham, Massachusetts

Red Blue, 1964
Oil on canvas, 90 x 66 inches
Collection Mr. and Mrs. Morton J. Hornick, New York

RECENT DEVELOPMENTS

ONE OF THE most dominant characteristics of Kelly's work through the years, other than his almost total preoccupation with shape, has been the way he consistently calls upon tension to achieve pictorial interest and vitality. It is also a large part of the content of his art. Tension, inevitable in life, is of course necessary to art. The artist's problem is how to create it and at the same time control it.

In the earlier work, and until about 1965 or so, Kelly relied mainly on variations of two kinds of tension-producing situations: one, in which the shapes within the space of the picture act against one another, and the other in which the shapes put pressure outward against the constrictions of the space in which they are trapped. The earliest example of the first mode was *Kilometer Marker,* 1949 (page 21), wherein the pressure of an aggressive curve upward meets the equally insistent downward pressure from the horizon line (reinforced as it is by its spatial weight above). When round and straight meet—the ball on the floor, the egg on the table—precariousness and unpredictability come into the picture. The artist's solution then must turn back toward quiescence, or at least balance. In such a picture as *Rebound,* 1959 (page 70), where soft meets soft (like the pressurized curves of two balloons) but is designed hard and crisp, it is difficult to tell which way things will go. Unlike the curved and the straight above, it is not a clear stand-off; the black space could expand or contract depending on future events. But Kelly, through the precision of the drawing, the surface tension across a texturally undifferentiated field of canvas, and perhaps because he has made this a "night" picture (where white is form and black is void), succeeds in suggesting the possibilities without leaving us in doubt about the outcome.

In his *Red Blue,* 1964 (opposite), round curve again meets straight line, this time the edge of the canvas, a more forceful conclusion perhaps than the gravity implied in *Kilometer Marker*'s horizon. Here Kelly breaks an old rule laid down in the days of representational illusionism: "A shape must be either in the rectangle or convincingly mostly out of it—but never tangential to a side." The rule and Kelly's exception to it are exactly the difference between the old and the new schools. The old rule was based on the experience of a fact; if a form

Black Ripe, 1956
Oil on canvas, 63 x 59 inches
Collection Mme Raymonde Zehnacker, Paris

or shape is tangent to the edge of the rectangle, it destroys the illusion of depth and creates a lateral tension, drawing the eye to the surface. In this case, it works perfectly in the breach; he wants his shape to lie on or above the surface (like a good Byzantine artist, he adjusted the value of the blue "background" space to compete for room with the red figure). This lateral pressure against the edge, supported by incipient pressure in the lower left, increases the whole "surfacing" of the picture so that the sensuousness of the colors and the line is analogized again in the literal touching of the limiting edge. But again the picture's tensions are cooled by the general elegance of its physicality.

In *Black Ripe,* 1956 (page 73), there are pressure points on all four sides of the near-square in which the undulating shape is enclosed. The shape itself was copied from a small, two-inch square drawing made on cardboard; it is clear from the sketch that the tension resulting from crowding was planned from the outset. It was noted earlier that Kelly had been fascinated with the pendentives of the crypts at Tavant, where the Romanesque painters had had to crowd their lively figures into confining spaces; and he had been equally drawn to stone figures of saints fitted tightly into coffinlike niches or cramping their elbows and knees together to hold columnar positions in the portals of French cathedrals. The lateral expansion and compression of energies and forces is one of several tension-themes he has developed.[54]

Black Ripe, of course, has a biomorphic quality that probably increases our psychological response to its imprisonment. *Bar,* 1956 (page 63), derived from a drawing of a pant leg but composed of straightened lines, has a little less of this kinesthetic attraction. In *North River* (page 69) even more distance is put between us and the squeezing of the image, but it still functions, especially in the middle ear, as more than a purely mechanical problem of misalignment. Unlike Malevich's famous cocked square within a square (*Suprematist Composition: White on White,* 1918?, The Museum of Modern Art, New York) and many other similar works, *North River* is not an arbitrary arrangement of an element or elements in the rectangle; it is instead the delineation of a very particular kind of tension derived from observation.

In 1965 Kelly painted two pictures related to *North River: Green Red* (Collection Nelson Rocke-

feller, New York)[55] and *Dark Blue Red* (Collection R. K. Greenberg, St. Louis). In both cases a large rectangle is slid into a slightly larger field of color with very little room to spare on either side. The inserted shape is tangent to top or bottom, but is embraced by the thin arms of the ground color on its sides. In *Green Red* the insertion is from the bottom; the other is from the top. Despite the similarity of composition, the two pictures are entirely unique, though each is based on the principle of abated tension—abated because the broad expanse of the blue or green introduced into the red field has such an equanimity of surface, as well as extent, that the precariousness of its pressures against the sides is visually dissipated by its seeming stability.

More mysterious and less describable kinds of tension exist in most of the panel pictures Kelly has painted since the late 1960s. *Black over White,* 1966 (opposite), is higher than it is wide, though at first it appears to be square. Moreover the black panel above is not a segment of a grid; that is, it is not precisely a quarter of the whole field, though it might seem to be on cursory inspection; neither does it have anything to do with Golden Section geometry. The decisions that went into its making were arbitrary and intuitive. At the same time, in the back of the spectator's mind lies the residue of his visual experiences with the geometry of architecture and general design, in the same way perhaps that the ideal human figure of a particular culture (ours is probably still Greek) lies behind his appreciation and expectancies when he views any painting of a nude. A sense of the variance between that geometric residue and the image Kelly has presented in *Black over White* adds to the tension in the proportions. By his title Kelly has provided a clue to his intent; the black is *over* the white, and despite the fact that it is not nearly so large as the white area, it lowers like a heavy, dark cloud. In reproduction, the painting may "read" only as a graphic image, but in the actual work, wider than a man's extended arms' length and taller than any normal person, the lintel of dense black has real weight. It takes all of the airy and spacious white to support it; in fact, Kelly has balanced the situation exactly with a typical tautness. Had there been proportionally more white or less black, the picture would have gone slack.

Since Kelly is by nature a "minimalist" and always has been, long before minimalism came into

Black over White, 1966
Oil on canvas, two joined panels; overall, 7 feet 2 inches x 6 feet 8 inches
Collection L. M. Asher Family, Los Angeles

being, he has had to find and refind the very essence of every potentially usable art idea. Unlike a more lyrical or expressionist sort of artist, he cannot depend on stumbling into a solution halfway through a painting. This is one of the reasons why drawings and collages lie around for a long time until he has found a way to go about making them into full-scale works of art. Even when most of his work came more or less directly from observations made of nature or architecture, the subject was a source, not a solution. When he began to reflect on his own work, to study alternatives to past solutions or old ideas that were good but not complete, he found he could take something like the panel out of the tentativeness of its early uses and make it work for him in new ways.

The early panel pictures, as has been stated elsewhere, seem to have issued initially from altarpieces, windows, shutters, and the organized fenestration of building façades. In the late 1950s his images had grown more complicated, or at least contained more incident within the painted rectangle. He had sometimes used (in *Atlantic*, page 56, for example) the panel structure, but it was not until the mid-'60s that he reverted to the concentrated use of uninflected panels in the way that he had with *Painting for a White Wall*, 1952 (page 42). This time, however, perhaps recalling the early Spectrums with which he had experimented but found somewhat wanting, he began to look at color again for itself and set out to discover the simplest means for matching it to the shape of its site. Since he had his own precedents to work from, he could leap over those set for other painters by Barnett Newman, Mark Rothko, and the younger, emerging colorfield painters. Had his own early work in this direction been known in this country (it was not shown in any depth until the "Art of the Real" exhibition at The Museum of Modern Art in 1968), the history of color-field painting might have been different.

In 1962 Kelly had made a color sketch composed only of the three primaries (Study for *Three Panels: Red Yellow Blue, I*).[56] The following year he turned this into a painting now in the collection of the Fondation Maeght in Vence, France. In this he weights the colors from hot to cool, rather classically giving the red a small, square box at the lower left; then he increases the area of the yellow by making it an ell-shaped panel fitted to the red square, culminating in an even larger area of ell-

shaped blue. Two things followed as a result of this painting: first, the vivification of his color through the pursuit of spectral organizations, and second, the creation of odd-shaped panels to be joined together into images unavailable by more conventional means.

The isolation of the primaries as a color-world big enough to work with in and of itself was not a momentous event in the light of Mondrian's precedent. But in Mondrian's philosophy, red, yellow, and blue represented the whole universe as essentialized, and as such he used them as symbolic elements. By weighting them, arranging them, or expunging one or another, Mondrian could, he believed, conjure up an aspect of "reality." Kelly's point of view, while perhaps inherently or unavoidably symbolic, leans much more toward a kind of pure sensualism and *joie de vivre*. Yet his Spectrum pictures, ranging from just the three primaries to doubled combinations of the primaries and the secondaries (as in *Spectrum, III,* 1967, opposite) are composed of shapes first and colors second. The shapes themselves are most often nothing but rectangles, from square to elongated, but they are shapes to be distinguished by the colors assigned to them. Of course each hue is adjusted with great care, but only to insure that each shape is clearly present and that none will lose that presence because of the strength or weakness of its surface color. What disturbed him most about his earliest *Spectrum* (1953) was that two of the hues at the center were too close in value, and thus the distinctiveness of the vertical rectangles was lost.

At the time the Spectrums and allied pictures began to appear in the mid-'60s, most observers thought they were first and foremost about color; some even read them as mere color charts and imagined that Kelly got his cues from Munsell's graded system. But if one compares several of these works side by side, it becomes immediately apparent that virtually no two blues, reds, or yellows are alike, and that in each case the variance is relative to the shapes of the panels and their areas. It would also seem that the reason why he reverts consistently, whenever major changes of shape and scale come about, to black and white, is to check out in the clearest possible way what is going to be required of renderings in color.

In 1956 he had been attracted to the way various-sized pictures displayed on a wall at a Juan

Spectrum, III, 1967
Oil on canvas, 13 joined panels; overall, 33¼ inches x 9 feet ⅝ inch
The Museum of Modern Art, New York. The Sidney and Harriet Janis Collection, 1967

above: *Painting in Five Panels,* 1956
Oil on canvas in five parts; overall, 36 inches x 12 feet
Collection Mr. and Mrs. Charles H. Carpenter, New Canaan, Connecticut

opposite above: *Blue on Blue,* 1963
Painted aluminum, 7 feet 4 inches x 60 x 6 inches
Collection Mr. and Mrs. Frederick R. Weisman, Los Angeles

opposite below: *Blue Disk,* 1963
Painted aluminum, 70 inches x 6 feet
Collection the Wasserman Family, Chestnut Hill, Massachusetts

Grís exhibition formed a kind of gestalt. From this experience he had created a group of paintings, also varied in size, to be hung together as one (*Painting in Five Panels,* opposite). It is clear that such an idea, going back to some earlier tentative considerations when he was in Sanary, of grouped single canvases in an architectural setting, was still in his mind when he applied it to his primary, and ultimately full, Spectrums. (The spectrum format is not always to be taken simply as red, orange, yellow, green, blue, indigo, violet, but for purposes of discussion also applies to those grouped color panels, separated or joined, which add, subtract, or replace the scientific light-spectrum colors with black and white and intermediate hues.) Thus, in addition to joined panels, he worked on spaced groupings. The reason often given for this is that the intervening wall space plays a positive role. It does, in the sense that the shapes of the panels become more defined. But this intervening space also increased the range of color possibilities; some hues could now be more aggressively individual, since the gap between panels prevented—even more than the visible joint already had—that optical mixture so dear to the Impressionists and to the Op artists who exploited it. Such a running together of colors along the seam of their jointure was anathema to his first concern, the positiveness of shape.

This obsession with shape is everywhere present in Kelly's work. In the beginning he saw his subject matter as an object to be expressed in terms of shape, and ultimately shape itself became the subject. For a while he had concentrated on shapes lying flat on the field of the rectangle. In the mid-1960s he also lifted the shapes literally out of the field and positioned them a few inches out from the surface (*Blue on Blue,* 1963, above right). He even went so far as to discard the rectangle altogether, permitting the shape to become a freestanding, thin, and relatively two-dimensional object more or less intended to be seen against a wall (*Blue Disk,* 1963, below right). The logic and the step-by-step chronology of these moves is so consistent with his own history as an artist that one cannot really talk about influences coming from the work of other artists during these years—except as a confirmation that what he was doing was beginning to be paralleled by others, but with different intentions. Like any strong artist working out of his own historical determinism, however, his

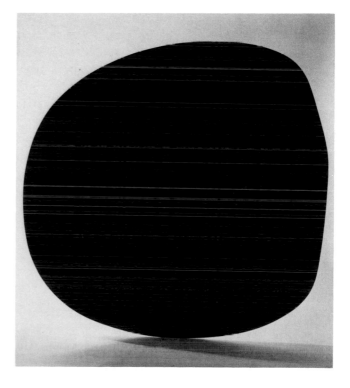

peculiar individualism was often misunderstood. Part of the problem resulted, then and now, from the critics' rush to label everything before the paint is dry, assuming that every artist is running to join their factitious movements and to learn from their theories. Kelly, for example, was using the clear-cut contour for his shapes long before he was coupled with a few other artists and called a "hard-edge" painter; and he was making reliefs and canvases that portended his own use of odd-shaped canvases long before the "shaped canvas" and "framing edge" theoreticians entered the field.

Kelly's approach to the shaped canvas has little or nothing to do with theories in any case, since its second phase evolved out of the simple panels of color he had used in the early 1950s and again in the early 1960s, and not out of any figurative design established within such a thing as a "framing edge." As has been noted above in connection with the three-panel Fondation Maeght picture of 1963, ell-shaped panels had been devised and the picture built by simple, orderly accretion. After having made a number of Spectrums with joined or separated rectangles and squares, and having found ways to make the appropriate adjustment of hues, he moved toward solving the question in terms of different-sized areas and related but different-shaped perimeters.

The tensions he had created in the neatly placed side-by-side panels of spectral color by the delicate adjustment of hue to area, existed because he had intervened where viewers tend to make forward and backward spatial associations in that range; blue is still thought of as recedent, airy, and spatial; yellow as formally weak and intermittent in its ability to hold a plane; red as hot and expanding. He had left the colors their qualities but not all their associations, forcing them, so to speak, to come out naked. In *Black over White* (page 75) and related pictures, he had continued an old practice: manipulating the relative size of panels for expressive purposes. These were usually oriented in horizontal orders. In the new variable-sized and -shaped panels from 1966 on, the orientation was not consistently horizontal, vertical, or linear, but was adapted to whatever overall conformation seemed worthwhile. Thus rhomboids, isometric projections, diamonds, truncated triangles, and banner shapes, as well as assembled regular- and irregular-sized rectangles, appear on into the 1970s

in a profuse array of questions asked and answered. Yet even all these shapes are reflexive, going back to suggestions in old collages. Often studio accidents are a source of new visions; a partly blanked-out collage or colorful piece of paper may set in motion a new way of seeing a set of shapes.

Curious things happen. *Red Yellow Blue, V,* 1968 (opposite), flies on the wall like a truncated nautical flag. The tapering toward the right could give the impression of a perspectival illusion, a decrescendo digging into the wall; it does not, in fact, because the color adjustments keep it lying on the surface and reinforce its true shape. Again the physicality of the panels, with their visible seams, helps to keep it palpably *there.* Kelly is so confident in this picture that he can use colors normally considered recedent in the conventional order and yet hold the distant blue in the same plane with the others. Kelly has said that he "is primarily concerned with 'naming' colors";[57] by insuring that the shape a color occupies has a specific and undeniable identity, he prevents color from escaping into sensuous generalization. Color, after all, as a phenomenon is far more complex, subjective, and unreliable than the simple shapes Kelly employs to capture it.

Along with the Spectrums and related banners, Kelly continued to work with two-color combinations. Strangely enough two colors present more difficult problems than three or more. Several hues together guarantee in advance a certain amount of automatic visual excitement even if they do not guarantee good pictures. To compete with the Old Masters—and the New—with only two colors and no activated surface, is like taking David's role against Goliath, but even David had five stones.

In an ambitious work, *Series of Five Paintings,* 1966 (pages 82–83), he tested an idea he had considered since 1950. His hope then had been one day to create works of art that would be large enough and strong enough to have an effect on an architectural environment. His three-dimensional mural and space-dividers in the Philadelphia Transportation Building (page 62) had not completely satisfied him, largely because of the installation. The *Series of Five Paintings* was made in such a way as to virtually insure that the canvases would fill an architectural space to the brim, controlling it and giving it an unshakable rhythm of shape, color, and dominant meaning. The group is composed of paintings of equal size, based on architecturally

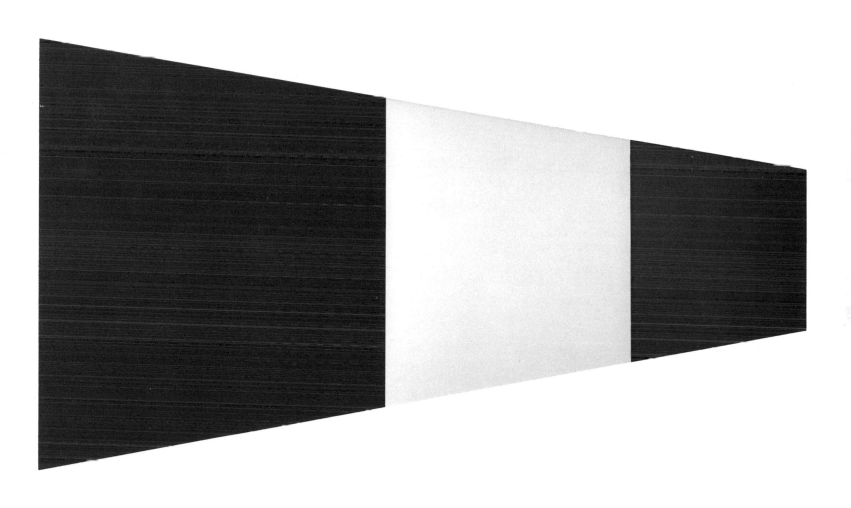

Red Yellow Blue, V, 1968
Oil on canvas, three joined panels; overall, 7 feet 5 inches > 36 inches x 13 feet 10 inches
Collection Mr. and Mrs. Frank H. Porter, Chagrin Falls, Ohio

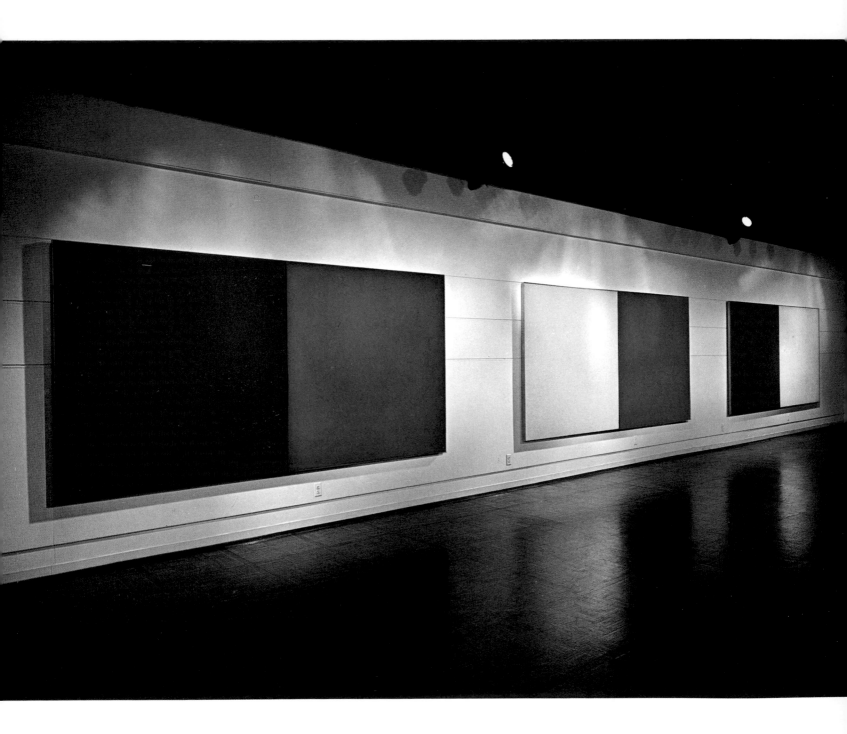

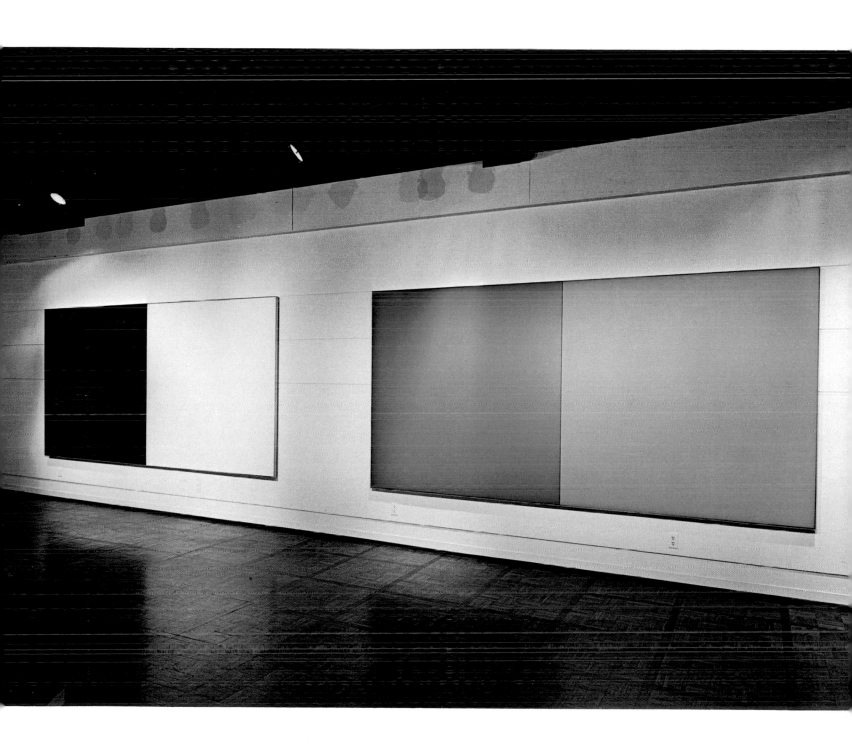

Series of Five Paintings, 1966
Oil on canvas in five parts. each, 70 inches x 11 feet 8 inches
Collection Geertjan Visser, on loan to Rijksmuseum Kröller-Müller, Otterlo, the Netherlands

White Sculpture, 1968. Painted aluminum,
8 feet 4½ inches x 12 feet 2½ inches x 38⅝ inches
Private collection, New York

Cowboy, 1958
Oil on canvas, 45 x 43 inches
Collection Jacques Neubauer, Paris

neutral squares paired in rectangles of two colors. Each unit is an easel painting in itself and could function as such, but when the group is properly installed, the individual paintings speak to each other across space in such a way that a total environment is handsomely achieved.

Tensions in this series were purposely kept to a minimum so that the overall environmental experience could take place. In other, single pictures, however, Kelly continued to seek situations wherein the individuality of the experience would be specific and leave the viewer with a distinct afterimage. A few of these test the possibilities of seemingly exotic shape, "seemingly" because upon inspection they are discovered to be based on the same general principles of bending and flattening that lie behind so much of his work from the beginning. In *Red Green,* 1968 (page 85), for example, the perspectival implications are frustrated by the insistence of the flat planes of color and even more by the factuality of the joint. How clearly this last functions in destroying otherwise inherent illusionism has been demonstrated by Kelly in other ways. In the process of making several two-color pictures based on isometric extensions of a large square, some of the smaller preliminary canvases were painted on a single stretched surface, the external shape of which conformed to the perimeter of the silhouette of the face and two sides of a cube. In these the illusionism is nearly total, despite the fact that two sides are painted in one continuous flat color. His use of strong and projecting color contrasts did little to allay the illusion of three-dimensionality. But when, in constructing a larger version, as in *Blue Green,* 1968 (page 84), the square was one actual panel and the area conforming to the sides of a cube was another panel, the imaginary diagonal where the bend would occur was largely erased by the recognizable carpentry of the two areas. The two solutions each evoke a different type of response. When the illusion is total and unavoidable, the viewer is so involved in the cleverness of the conceit that his sensuous reaction to the shape and the colors tends to distract from rather than add to his experience. In the instances where the quasi-illusion is balked because the colors and the shapes loom first in the eye, the latent aspects of the picture's geometry form a kind of reservoir of potential material to be called upon, like iconography in religious painting.

Bending and flattening, as Kelly uses them, are not intended to set up illusionistic conceits but to engage the viewer in a dialogue with the work, to make it a participatory experience involving discovery. This goes back to his own discoveries: how surprising shapes and patterns are created by shadows and reflections, how the truth of a phenomenon is often withheld by an appearance that has its own equally valid truth, how something that is normally bent (the shadow of the bridge arch) when flattened (*White Plaque,* page 51) presents a new face, and how a thing that is normally flat when bent does the same. This becomes clearer perhaps in the later work and particularly when seen in conjunction with his sculpture.

The earlier free-standing pieces such as *Gate,* 1959, and *Blue Disk,* 1963 (pages 71 and 79), were lifted out of their figure-ground context, and a few of the more recent pieces have been retrieved from collages and paintings of the late 1950s; compare, for example, *White Sculpture,* 1968, with *Cowboy,* 1958 (opposite page). But having thoroughly abandoned ground in the process of making these sculptures, and having entered upon the creation of such things as the color panels, which in a sense are both figure and ground at the same time (unless one considers the wall as the ground), Kelly was both logical and ingenious in his move to bend a flat panel into actual space. He tried it in canvas first, but the cumbersomeness and the fragility of the result quickly led him to the more permanent and lightweight aluminum. *White Angle,* 1966 (at right), and a blue and white companion piece were the first of these. Meanwhile, having begun making pictures with triangular and rhomboidal shapes, as well as variations on the rectangle, often suggesting that the flat was bent, he made sculptures that suggested just the opposite. From any one position these sculptural pieces (see *Green Blue,* 1968, and *Yellow Blue,* 1969, pages 100 and 88) appear totally flat, totally camouflaged as to what they literally are. And as Barbara Rose has noted: "Since the surfaces are painted a matte color, light does not reflect from them; similarly, because a plane is flat and unbroken, shadow cannot accumulate in any indentations. Compensating for the lack of light and shadow contrast is the very strong and specific sensation of color, which is as brilliant and forceful in its impact in the sculpture as it is in the paintings."[58] When one moves past they remain frontal,

White Angle, 1966
Painted aluminum, 6 feet x 36 inches x 6 feet
The Solomon R. Guggenheim Museum, New York. Gift of the artist

with a maximum visual life of one hundred eighty degrees, and are meant to be positioned against a backdrop of wall or foliage. The true shape of the whole piece is never available, any more than one can see a sculpture-in-the-round in the round.

The bending in these sculptures along divisions that correspond to the joints between panels in the paintings tells us something about the latter. They almost always contain a suggestion of the possibility of bending, even to the point of a breaking or separation of the parts. It is hard not to recall Kelly's early involvement with swinging altarpiece panels, with French windows and shutters, with potential movement or displacement. And just as the bent planes of the sculptures pull their surfaces into tautness (they are rarely turned a full ninety degrees; thus the adjacent planes stretch like skin from one to the next), the bending potential in the paintings heightens the sense of tautness in a way consistent with the tightness of his colors and canvas surfaces. But the bending potential remains just that; it is a kinesthetic projection, not an illusion, and the very factuality of the joints aids in making that clear.

Kelly's introduction of triangles and diamond-shaped canvases into his vocabulary of forms in the late 1960s and early 1970s did not represent a major innovation on his part. These shapes were being used for various kinds of painting by any number of artists: Liberman, Newman, and Noland, among others. Since shape had always been Kelly's province, he would have got around to these sooner or later, regardless of any stylistic milieu. In any event, Kelly's vocabulary of forms has its own dictionary. He enlarges upon it, as has been noted above, in a reflexive way; or he is stimulated to add a form from something visually new to him in the environment. For example, *Green White*, 1968 (opposite), resulted from an encounter with a young lady walking in Central Park and wearing a scarf on the nape of her neck. He followed her for some distance until he had memorized the exact areas of the green and white in the triangle of silk. After this developed into a pictorial idea, the triangle began to appear in other contexts and modifications (see *Black White*, 1968, and *Black White*, 1970, pages 91 and 90).

The small shape versus the large, as separate but joined entities, appears as a theme in the 1970s. In some instances, these follow the horizontal formats

Yellow Blue, 1969
Painted steel, 9 feet 6 inches x 16 feet x 8 feet 6 inches
State of New York, Albany South Mall

Green White, 1968
Oil on canvas, two panels, 71 inches x 11 feet 9 inches
Galerie Françoise Mayer, Brussels

Black White, 1970
Oil on canvas, two panels, 70 inches x 9 feet 1 inch

90

Black White, 1968
Oil on canvas, two panels, 8 x 8 feet

within the classic rectangle familiar from the early 1950s (*Awnings, Avenue Matignon,* page 37, for example). But a real departure occurs when neither of these areas conforms to the other in such a way as to allow them to be fitted together to complete a conventional rectangular figure (*Black Square with Red,* 1970, opposite).[59] There is a tendency for the eye to make an imaginary completion, but it is hard to hold this fictional perimeter for long, because the colors and the shapes themselves are so insistently discrete. The formula looks simple, particularly in reproductions of the work, where they may be mistaken for graphic images. Perhaps here, even more than in previous paintings, physical size and relation to human scale is of major importance. The same is true of the 1971–1972 Chatham series (for example, *Chatham XI: Blue Yellow,* 1971, page 94), in which their great breadth and towering heights are the most affective aspects of them as paintings, quite aside from their brilliant colors. There is a strange quality, however, in the latter; because they are in essence portions of an imaginary rectangle, they have, despite their size, a lightness of feeling, a kind of April freshness about them that belies the severity of their shapes. It is as if they had been liberated from long confinement.[60]

Possibly because Kelly had pushed rectangular and paneled sequences as far as he could—and the tensions upon which so much of his content had been based had become too abstract—the long, taut, but graceful curve reentered his painting. It is not the curve of the biomorphic pictures, or the overblown curve of the *White Plaque,* or the parabolic curve of *Atlantic,* or even that of the Brooklyn Bridge group. It is more like the curve only lately familiar to us in the Gemini photographs taken from about a hundred miles out in space showing a segment of the earth's circumferential horizon. Long, flat, it describes a circle, the center of which is far outside the frame of the photograph, or in this case, far outside the frame of the canvas. It began to appear in Kelly's work in 1968. Having added the rhomboid to his set of overall shapes as an alternative to the rectangle, and having bent it on a line drawn between two opposite corners, as in the sculpture *Green Blue* and in a couple of pictures, he tried joining the corners with a curve. This meant giving up panel construction temporarily, because the idea of more complicated carpentry tended to freeze into geometry what he wanted to

Chatham XI: Blue Yellow, 1971
Oil on canvas, two panels, 7 feet 6 inches x 6 feet 5½ inches
Albright-Knox Art Gallery, Buffalo. Gift of Seymour H. Knox

Black Curve, II, 1971, 1973
Oil on canvas, 8 feet 4 inches x 8 feet 4 inches

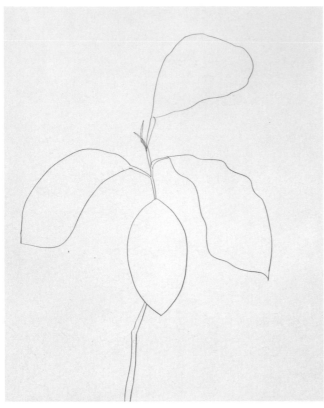

Orange Leaves, 1968
Pencil on paper, 29 x 23 inches

Branch of Leaves, 1970
Pencil on paper, 29 x 23 inches

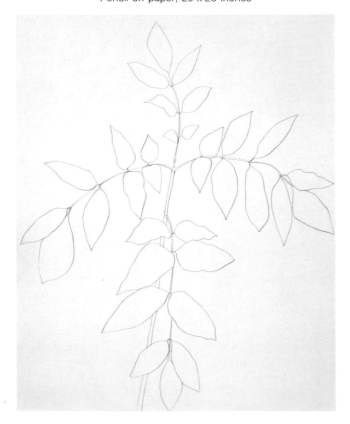

remain free-hand and speculative. Moreover the physical joint employed in the panel pictures worked as an accessory to the implied bending possibilities, a major source of vitalizing tension; actual bending along a curve requires soft materials. The contradiction would either visually explode the picture or turn it into a jig-saw puzzle. In other words, panel construction would defeat rather than enhance the visual content of the paintings involving curves. But the curve, in turn, made up for the loss of the panel by introducing other sources of tension and vitality.

Curves produce a sense of volume and/or perspective when they are the edges of shapes; in essence they bend into space, either as flat and receding planes or expanding volumes. Given the kind of taut surface and flat color areas Kelly uses, his curved shapes (for example, *Black Curve II,* 1971, 1973; *White Curve,* 1972; and *Red Curve, II,* 1972; pages 95, 98, and 99) lie in an ambivalent limbo between spatial and volumetric expressions, even as they assert their actual flatness. Beginning with the external shape of the rhomboid, and painting the areas in two colors as in the past, he went on to bannered triangles, right-angle triangles, and that slightly squashed rhomboid, the diamond. In the best of these, the external shape supports the curve; in others, the curve supports the shape in a process that renders each more visible and real and creates a living dialogue that does not fade after first viewing. Others seem somewhat unsteadier; but as with all work in progress, questions arise that can only be answered by time and further developments.

THE PLANT DRAWINGS

IN THE SPRING of 1949, Kelly, then living in Paris, bought a potted hyacinth and took it home to cheer up his room. It became a subject for drawing (page 28). It was, in a sense, a surrogate for the portrait drawings that no longer interested him, probably because the human figure, no matter how abstractly handled, asserts a personality over which the artist has no control. From that time forward, though he filled his sketchbooks with drawings of architectural elements, reflections, and shadows, gathered as ideas for paintings, he would occasionally make careful, composed line drawings of plants, not intended as sources but as works of art

in themselves. A steady stream of these drawings began to appear about 1957 and continues to the present.

At the School of the Museum of Fine Arts in Boston he had been exposed to "contour" drawing, which in Paris he would sometimes practice in its purity; but in the Paris years, such simplified clarity of shape was for the most part expressed in his reliefs and paintings. It was in New York, where he kept a studio corner filled with potted plants, that the style of drawing for which he is known developed with consistency. This subject matter appears to have been a foil for the increasing abstractness of his paintings, as Barbara Debs Knowles has pointed out.[61] The same critic also places strong emphasis on the influence of Matisse's line drawings and the French artist's late cutouts. But if one recalls Kelly's early passion for Audubon and, later, that for the Russian Rublev, it is possible to see that a strong predilection for contour had persisted for many years. In his first months in Paris, for example, he recalls returning again and again to the Louvre to look at the Egyptian *Stele of the Serpent King*.[62]

It is also probable that his short foray into the surprises of automatic drawing in the summer of 1950 freed him even more from any need to deal with shading, or indications of it such as fattened and emphasized lines, to capture that degree of space and volume requisite for naturalistic rendering. Their economy of means is, of course, the first most noticeable thing about these drawings; their seeming accuracy in the horticultural sense is next (though in fact the naturalist's eye has been thoroughly subjected to that of the artist). But it is ultimately the ordering of the shapes, their placement on the page, and the tension between the line and the shapes it describes that bring us to recognize the combination of toughness and sensuousness in Kelly's work that is rare in drawing. In the late, shaped canvases the perimeters are hard and tough, as are the curved edges of the shapes; sensuousness is achieved by color. Here both are achieved through line. This combination is probably really a definition of all that we call elegance.

Lily, 1960
Pencil on paper, 28½ x 22½ inches

Artichokes, 1961
Pencil on paper, 22½ x 28½ inches

White Curve, 1972
Oil on canvas, 8 feet 4 inches x 8 feet 4 inches
Stedelijk Museum, Amsterdam

above: *Red Curve, II,* 1972
Oil on canvas, 45 inches x 14 feet
Stedelijk Museum, Amsterdam

overleaf: *Green Blue,* 1968
Painted aluminum, 8 feet 7½ inches x 9 feet 4½ inches x 68½ Inches
The Museum of Modern Art, New York Susan Morse Hilles Fund

NOTES

1 Arthur Wesley Dow was head of the art education department of Teachers College, Columbia University. His pedagogical ideas, along with those of the philosopher John Dewey, were most influential in elementary and secondary art training from 1895 to 1930. Dow's theories preceded those of the Bauhaus by twenty-five years and were based on an analysis of underlying universal principles in all the arts. Georgia O'Keeffe, who studied with him in 1915 and carried his ideas into her teaching in West Texas, has said in conversation that Dow "gave you a basis for looking at anything." His theory of light and dark was based on the Japanese concept called "notan." See Arthur Wesley Dow, *Composition* (New York: Doubleday, Doran & Co., 1899, 1913).

2 Graves was the author of *The Art of Color and Design,* 1951 (reprinted New York: McGraw-Hill, 1973).

3 From the "Official History of the 23rd Headquarters Special Troops," written by the Reverend Fredcric Fox, now Recording Secretary at Princeton University. The Reverend Fox's document, authorized while he was still a member of the 23rd, of which the 603rd was a unit, gives a detailed account of the movements of these troops from January 20, 1944, to deactivation in September 1945. Upon reading this document, Kelly was able to pinpoint a number of his sketches of the period made during operations in France. He says: "Everybody was sketching all the time, and it was while I was in the outfit in France that I decided to become a painter," meaning that he was to change his direction away from applied arts. He recalls that Bill Blass, the fashion designer, and Albert Landry, the gallery director, were in the 603rd, as well as Olin Dows, Alan Wood-Thomas, and Bill Griswold.

4 Thayer was an American romantic portraitist who started out as a painter of animals, studied with Gérôme in Paris, and in America was associated with such people as George de Forest Brush, J. Alden Weir, Helena de Kay, and Dwight W. Tryon. He is perhaps better known to military historians than to contemporary artists.

5 In a letter to the author, dated October 17, 1972.

6 Bill Griswold actually posed for Picasso, who painted him as a French sailor.

7 Kelly filled a small sketchbook with portraits of these people who, in their boredom, were happy to sit. The drawings themselves are documentary evidence rather than measures of Kelly's development.

8 Among the many works Kelly recalls from his museum-going in Boston, three stand out most vividly. Two of them, Matisse's *Carmelina* and *The Terrace, Saint-Tropez* (Figs. 1 and 2), fascinated him because of the way Matisse dealt with light and shadow: in *Carmelina* he used them to express the volumes of the model's figure most vividly and to create an intricate pattern throughout; in *The Terrace* he had split the canvas in two with a diagonal marking the edge of the dark and light areas. Patterns of dark and light have been major sources of subject matter and design for Kelly.

The third, the frescoes of the Catalan apse from Santa Maria de Mur (Fig. 3), whetted Kelly's appetite for the Romanesque. The emphasis on shape and simple, flat color were to be the basis of his art in years to come.

9 When Kelly first saw the mica serpent (Fig. 4), it was on loan to the Boston Museum of Fine Arts. As a clear-cut,

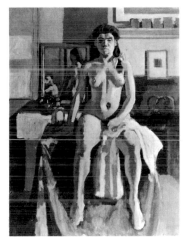

Fig. 1 Henri Matisse, *Carmelina*, 1903. Oil on canvas, 31½ x 25¼ inches. Museum of Fine Arts, Boston. Tompkins Collection

Fig. 2 Henri Matisse, *The Terrace, Saint-Tropez,* Summer 1904. Oil on canvas, 28¼ x 25¼ inches. Isabella Stewart Gardner Museum, Boston

Fig. 3 *Christ in Majesty,* 12th century, from the apse of Santa Maria de Mur, Catalonia. Museum of Fine Arts, Boston. Maria Antoinette Evans Fund

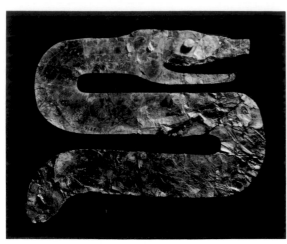

Fig. 4 Mica serpent, Algonquin burial mound, Madisonville, Ohio, found in 1882. 10¼ x 13 inches. Peabody Museum, Harvard University, Cambridge, Massachusetts

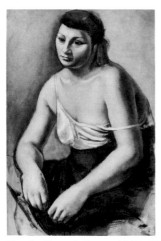

Fig. 5 *Seated Figure,* 1947. Oil on panel, 36 x 24 inches

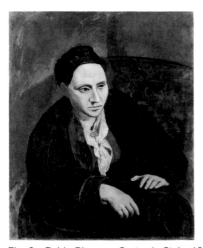

Fig. 6 Pablo Picasso, *Gertrude Stein,* 1906–1907. Oil on canvas, 39⅜ x 32 inches. The Metropolitan Museum of Art, New York. Bequest of Gertrude Stein, 1946

almost stamped-out object, neither a sculpture nor a painting, it could have been more meaningful to him than to other students because of his stencil-cutting days in the Army. Stencil-cutting implies finding the most telling silhouette to fully describe an object. The taut interaction between shape and space is a recurrent quality in Kelly's work.

10 Kelly was still involved in the expression of volume through shading in the *Seated Figure* (Fig. 5), but his design of the head and its elements—eyes, nose, and mouth—all demonstrate a new and deep concern with shape. The influence of early Picasso is immediately apparent in *Seated Figure* when compared with the Gertrude Stein portait (Fig. 6), available in reproduction. Some months had passed between *Self-Portrait* (page 15) and the *Seated Figure,* which still has overtones of the "fast" illustrative style he had acquired at Pratt.

11 These letters appear in their entirety in Peter Selz, *Max Beckmann* (New York: The Museum of Modern Art, 1964), pp. 132–134. They were read originally to students at Stephens College, Columbia, Missouri, on February 3, 1948; Beckmann later made similar appearances at the Art School of the University of Colorado, Boulder, and Mills College, Oakland, California. Underneath a certain romantic tone, Beckmann laid out some basic principles that may have had an effect on Kelly's development:
"Don't forget nature," Beckmann writes, "through which Cézanne, as he said, wanted to achieve the classical. Take long walks and take them often, and try your utmost to avoid the stultifying motor car which robs you of your vision, just as the movies do, or the numerous motley newspapers. Learn the forms of nature by heart so that you can use them like the musical notes of a composition. That's what these forms are for." But, he says, "nothing is further from my mind than to suggest to you that you thoughtlessly imitate nature. The impression nature makes upon you must always become an expression of your own joy or grief, and consequently in your formation of it, it must contain that transformation which only then makes art a real abstraction. But don't overstep the mark. Just as soon as you fail to be careful you get tired, and though you still want to create, you will slip either into thoughtless imitation of nature, or into sterile abstractions which will hardly reach the level of decent decorative art."

12 *Man in a Box* (Fig. 7) is reminiscent of Beckmann's brusque style, as in *Departure* (Fig. 8), but it also already suggests Kelly's later interest in Romanesque figures enclosed in tight spaces. The cocking of the box frees it from merely paralleling the picture frame. The minimal diagonal at the top as well as the more assertive one on the right appear in many of the abstract paintings of the late 1950s (for example, *North River,* page 69).

13 Besides Beckmann, Kelly recalls two other lecturers who came to Boston: Philip Guston, the painter, who spoke on Piero della Francesca, and Herbert Read, the British critic, who, he remembers, stated that easel painting was over for the time being and that the next move would come about through a collaboration between art and architecture.

14 Onni Saari, a fellow student and a close friend at the time, also had Paris on his mind, and they apparently convinced each other that it was absolutely necessary to go.

15 The elliptoid shape of the *mandorla* in Notre-Dame-La-Grande (Fig. 9) appears in many contexts. In *Female Figure* (Fig. 10) it is isolated and floats in space, somewhat in the way the *mandorla* floats on the cathedral wall. A number of

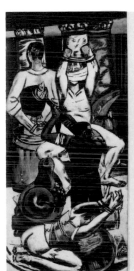

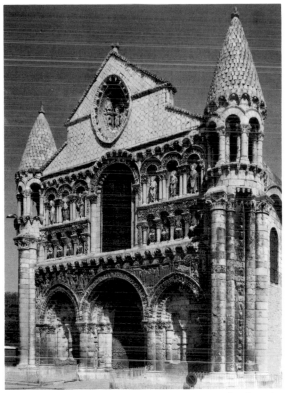

Fig. 7 *Man in a Box,* 1947. Oil on canvas, 30 x 24 inches

Fig. 9 Façade, 11th–12th century, Notre-Dame-La-Grande, Poitiers, France

Fig. 8 Max Beckmann, *Departure,* 1932–1933. Oil on canvas; triptych, center panel, 7 feet ¾ inch x 45⅜ inches; side panels each 7 feet ¾ inch x 39¼ inches. The Museum of Modern Art, New York. Given anonymously (by exchange)

Fig. 10 *Female Figure,* 1949. Oil on canvas, 36 x 24 inches

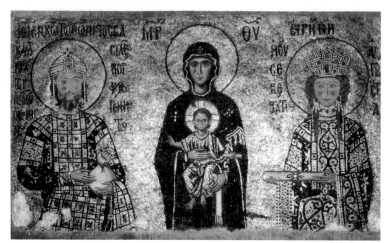

Fig. 11 *Virgin and Child Flanked by Emperor John II Comnenus and the Empress Irene,* ca. 1118. Mosaic of the south gallery, Hagia Sophia, Istanbul

Fig. 14 Exterior of apse, Cathedral of Tarbes, France, 12th century

Fig. 12 *Head,* 1948. Oil on canvas, 15 x 15 inches

Fig. 15 Pablo Picasso, *Student with a Pipe,* Winter 1913/14. Oil, charcoal, pasted paper, and sand on canvas, 28¾ x 23⅛ inches. The Museum of Modern Art, New York. Promised gift of Nelson A. Rockefeller, New York

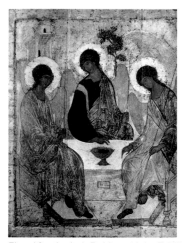

Fig. 13 Andrei Rublev, *Holy Trinity,* ca. 1410. Panel, 56 x 45 inches. Tretyakov Gallery, Moscow

Fig. 16 Study for *Window, I,* 1949. Pencil on paper, 7¾ x 5¼ inches

106

pictures from this period show the more contemporary influence of Picasso and Klee, however. The Picasso style is most clearly reflected in the freedom with which Kelly reconstructs the human figure at his pleasure, the influence of Klee shows itself in a certain whimsy and openness of space. But Kelly's search for his own kind of shapes is already evident.

16 Whittemore gave Kelly a photo of the Hagia Sophia mosaic (Fig. 11), and he used it as the basis for several pictures. The *Head*, 1948 (Fig. 12), is a close transcription of the head of the Empress. This head, like many Kelly was to draw and paint in the next year, is fitted tightly into its space; the undulating line of the hairline at the top and a similar handling of the hair show him to be moving more and more toward the designing of shapes and away from representation.

17 See Fig. 13. George H. Hamilton in *Art and Architecture of Russia* (Baltimore: Penguin, 1954), p. 87, says that Rublev was the Russian religious painter whose "substitution of a continuous contour for the impressionist broken outlines of Novgorod was his signal contribution to Moscow painting."

18 Kelly never went to Tarbes, but tucked in a sketchbook were photographs of this (Fig. 14) and other cathedrals.

19 From a statement by André Masson, *Arts Yearbook 3* (New York: Art Digest, 1959), p. 45.

20 For example: Jean Bazaine, Nicolas de Staël, André Lanskoy, Charles Lapicque, Georges Mathieu, Pierre Tal Coat, and Maria Vieira da Silva.

21 Picasso's *Student with a Pipe* (Fig. 15) is now in the collection of The Museum of Modern Art, New York.

22 Part of the sharpness of Audubon's bird images results from the fact that the watercolor drawings of the subjects, done from dead bodies supported in lifelike positions by an armature of wires, were cut out and affixed to appropriate scenic backgrounds. The latter were often executed by artists other than Audubon. The clarity of image and the purity of contour of the prints have had an influence on Kelly's drawing style and his whole feeling for "edge," not only in the paintings of the late 1950s, but in the unequal-panel pictures of the late 1960s and early 1970s.

23 The sketch for *Window, I* (Fig. 16) was one of these, and the roadside marker was realized in the painting *Kilometer Marker*, 1949. The shape of the marker bears a strong relation to the figure in Paul Klee's *Mask of Fear* (Fig. 17).

24 Asked if he had employed systems, such as geometry or the Golden Section, Kelly replied that he "never wanted to do anything that was open to everybody."

25 Walking along the street in Paris near the famous restaurant, Tour d'Argent, Kelly noticed that new asphalt had been laid over old, covering sewer operations. He paced off the street (note the distance points on the side) and drew the patterns made by the new asphalt (Fig. 18).

26 Kelly also photographed many of these details. The pattern created by the chimneys on the side of a building (Fig. 19) was realized in the central panel of a 1950 painting, *Ormesson*.

27 Among them: Kenneth Noland, Richard Stankiewicz, Sam Francis, John Levee, Paul Jenkins, and Kelly Williams, the black artist who now lives and works in Detroit. Williams drove a vehicle around Paris with "Kelly" printed in large letters on the side, leading some to confuse the two artists.

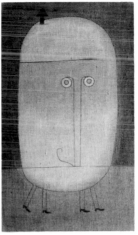

Fig. 17 Paul Klee, *Mask of Fear,* 1932. Oil on burlap, 39½ x 22½ inches. Collection Dr. Allan Roos and Ms. B. Mathieu Roos, New York

Fig. 18 *Street Pattern below Tour d'Argent,* 1949. Pencil, 13¼ x 3⅝ inches

Fig. 19 Building, Boulevard des Courcelles, Paris. Photograph by the artist

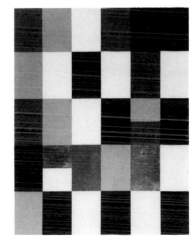

Fig. 20 Jean (Hans) Arp and Sophie Taeuber-Arp, *Duo-Collage,* 1918. Paper on cardboard, 33⅞ x 26 inches. Private collection, New York

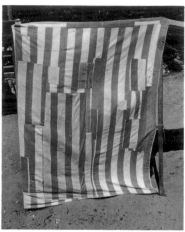

Fig. 30 Beach cabana, Meschers, France, 1950. Photograph by the artist

Fig. 32 Paul Klee, *Variations,* 1927. Oil on canvas, 15 x 15¾ inches. Galerie Alfred Flechtheim, Berlin

Fig. 33 Window, Museum of Modern Art, Paris, 1949. Photograph by the artist

Fig. 31 Exposed reinforcing rods from shelled bunkers, Meschers, France, 1950. Photograph by the artist

Fig. 34 Windows, Le Corbusier's Swiss Pavilion, Cité Universitaire, Paris. Photograph by the artist

Fig. 35 *Window, VI,* 1950. Oil on canvas and wood, 26 x 62¾ inches

Fig. 36 Rear of Swiss Pavilion, Paris

Fig. 39 *Study for Folding Painting,* 1952. Pencil and ink

Fig. 37 Matthias Grünewald, Isenheim Altarpiece, 1515. Musée d'Unterlinden, Colmar, France. Wings closed: The Crucifixion between St. Anthony and St. Sebastian

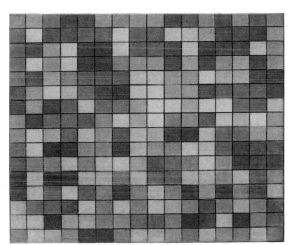

Fig. 40 Piet Mondrian, *Composition: Checkerboard, Bright Colors,* 1919. Oil on canvas, 33⅞ x 41¾ inches. Gemeentemuseum, The Hague

Fig. 38 Isenheim Altarpiece, first opening: The Annunciation, the Nativity with Concert of Angels, and the Resurrection

Fig. 41 Photos of Kelly with works from 1949–1950. Contact sheet sent to John Cage from Paris, 1950

Fig. 42 Arches in the Pont de La Tournelle, Paris. Photograph by the artist

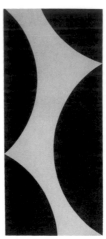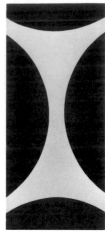

Fig. 45 *Brooklyn Bridge, IV,* 1956–1958. Oil on canvas, 30 x 13 inches

Fig. 46 *Brooklyn Bridge, V,* 1959. Oil on canvas, 30 x 13 inches

Fig. 43 Brooklyn Bridge pylons. Photo courtesy New York Department of Public Works

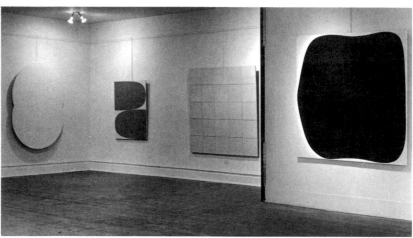

Fig. 47 Installation, Ellsworth Kelly exhibition, Betty Parsons Gallery, New York, 1956; left to right: *White Plaque: Bridge Arch and Reflection,* 1952–1955; *Red Curves,* 1955; *Two Yellows,* 1952; and *Black Ripe,* 1956.

Fig. 44 *Brooklyn Bridge Pier,* 1956. Ink on paper, 6½ x 5 inches

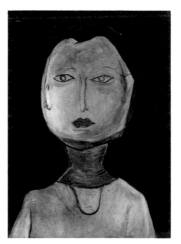

Fig. 48 *Figure in Yellow and Blue,* 1948. Oil on canvas, 24 x 17 inches

Fig. 49 *Tavant Head,* 1949. Oil on canvas, 25½ x 19½ inches

45 "Sixteen Americans," The Museum of Modern Art, New York, December 16, 1959–February 14, 1960. The others were J. de Fco, Wally Hedrick, James Jarvaise, Landès Lewitin, Richard Lytle, Robert Mallary, Louise Nevelson, Julius Schmidt, Richard Stankiewicz, and Albert Urban.

46 Reproduced in Waldman, *op. cit.*, plate 55. Kelly photographed the bridge in Paris that provided the image for his collage and painting (Fig. 42). The wider arch at right prefigures his Curves series of the 1970s.

47 Kelly sketched this phenomenon (compare Figs. 43 and 44) and later painted a series of works entitled Brooklyn Bridge, not all of which were directly related to their source (Figs. 45 and 46).

48 "Ellsworth Kelly," Betty Parsons Gallery, New York, May 21–June 8, 1956. See Fig. 47.

49 Of the Transportation Building mural, the critic Barbara Rose wrote: "Seen from different angles, the cut out sheets become a series of groupings or combinations of forms which change as the viewer moves from side to side and isolates different configurations as they come into his field of vision." In "The Sculpture of Ellsworth Kelly," *Artforum* (New York), vol. 5, no. 10 (Summer 1967), p. 52.

50 "Ellsworth Kelly," Betty Parsons Gallery, New York, September 23–October 12, 1957.

51 Among the new action painters were Rosemarie Beck, Helen Frankenthaler, Michael Goldberg, Paul Jenkins, and John Levee; among the figurative expressionists, Jonah Kinigstein, Jack Wolfe, and Jack Zajac.

52 Illustrated in catalogue of the exhibition "The 1958 Pittsburgh Bicentennial International Exhibition of Contemporary Painting and Sculpture," Carnegie Institute, Pittsburgh, December 5, 1958–February 9, 1959, plate 140.

53 See catalogue of the exhibition in *Derrière le Miroir* (Paris), no. 110 (October 1958); text in English and French by E. C. Goossen, published by Galerie Maeght.

54 The antecedents of *Black Ripe* go back to 1948–1949. At Tavant Kelly had stumbled on a loose stone head lying on the floor. Its primitive Romanesque shape appealed to him, and he made a sketch of it and later the painting, *Tavant Head,* 1949 (Fig. 49). Before this he had painted *Figure in Yellow and Blue,* 1948 (Fig. 48). The two heads seem to represent the beginning of such shapes as *Black Ripe.*

55 Reproduced in color in *Twentieth Century Art from the Nelson Aldrich Rockefeller Collection* (New York: The Museum of Modern Art, 1969), p. 118.

56 Reproduced in Waldman, *op. cit.*, plate 128.

57 Quoted in *ibid.*, p. 24.

58 Barbara Rose, *op. cit.*

59 Among Kelly's photographs of 1968 was this Long Island barn (Fig. 50), its shape relating to that of *Black Square with Red.*

60 Hilton Kramer in his *New York Times* (July 26, 1972) review of the Chatham series shown at the Albright-Knox Art Gallery in Buffalo wrote: "Sooner or later one cannot help noting that the division of rectangles in these paintings is, essentially, a division of light and shadow. This is most evident in the black and white paintings, of course, but even where

the colors are hottest, in the red and yellow pictures, the basic division of light and shadow makes itself felt. What we have in 'The Chatham Series' then, is a pictorial environment constructed of blocks of light and shadow. Oddly enough, a style that at first glance looks totally removed from any attachment to nature is nonetheless deeply evocative of a certain naturalistic poetry." Kramer's insight into these totally abstract paintings indicates how a perceptive eye can correctly divine the essential source of an artist's work.

61 Barbara Debs Knowles, "Ellsworth Kelly's Drawings," *Print Collectors Newsletter* (New York), vol. 3, no. 4 (September–October 1972), pp. 73–77.

62 See Fig. 51.

Fig. 50 Potato barn, Bridgehampton, Long Island, 1968. Photograph by the artist

Fig. 51 *Stele of the Serpent King.* Limestone, 4 feet 7½ inches high. The Louvre, Paris

APPENDIX

KELLY AND CAMOUFLAGE

CAMOUFLAGE as a survival strategy in nature and as the art of deception in warfare deals primarily with the breakup of forms either by protective coloration or the distortion of the true shapes of objects. In the first instance the fish, animal, or bird wears a skin or coat of patterns and colors that blend with those of the natural habitat. Similarly the military supplies its soldiers with splotched uniforms and paints its equipment in zigzag patterns with colors intended to blend with the background. But the shadows of an object are still a "dead giveaway" of its presence. So the military, to protect its vehicles and guns in parks or emplacements, has developed techniques for fracturing silhouettes and shadows. The most universal method is the erection of "fishnet" canopies woven intermittently with "oznaberg," a pliable material cut in three-inch strips that creates an open pattern on the surface and a jumble of confusing shadows on the ground.

Most of us are unaware of how much we depend upon shadows to interpret objects. To be in total light, as at sea or in the desert, is as blinding as to be in total darkness in the dead of night. An object without shadows is virtually nonexistent as far as vision goes. Also, a shadow without an apparent cause is mysterious and often frightening (the shadow of a hawk flying over the chicken yard). A shadow implies a cause, and any military observer seeing an unexplained shadow would immediately telephone his superior.

Every art student learns to express volumes by their shapes and shadows. He also learns to use shadows as part of the overall design of his paintings, as did Matisse in the *Carmelina* and *The Terrace, Saint-Tropez* (Figs. 1 and 2, page 103); in other words, he sees them objectively. But few artists have used shadows as Kelly has: as separate entities, as a source of abstract art. The disembodied shadow, as it were, nevertheless retains something of the quality of its cause, and this explains perhaps in part a certain naturalistic feeling in Kelly's abstract painting. Probably it is because his painting is less arbitrary, less of a pushing things around just to arrive at a pleasing (Euclidean) arrangement.

Not all of his work issues directly from shadows and their patterns, of course. Certainly he has indulged a purely abstract approach at times. But his work suggests that an eye and sensibility trained

as his have been to see in terms of real things derives its system of values and judgment from that experience.

His work also suggests that the experience with camouflage techniques and effects provided a background for his art: shape and shadows, bending and flattening, are all things that give his work its peculiar structure and coherence.

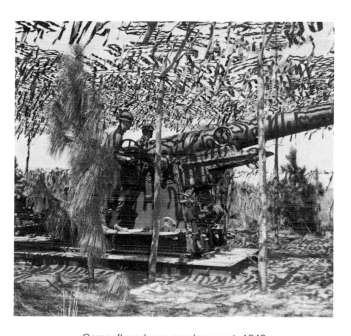

Camouflaged gun emplacement, 1943.
Oznaberg woven through net canopy casts shadows disguising site.
U.S. Army photo

Camouflaged headquarters unit;
center, Lt. Gen. George S. Patton with staff officers,
August 15, 1943. U.S. Army photo

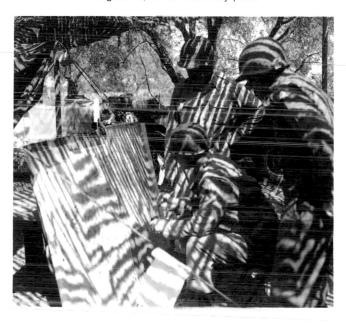

BIBLIOGRAPHY

MONOGRAPHS

1 Coplans, John. *Ellsworth Kelly*. New York: Harry N. Abrams, 1973.

2 Waldman, Diane. *Ellsworth Kelly Drawings, Collages, Prints*. Greenwich, Connecticut: New York Graphic Society, 1971.

GENERAL REFERENCES (BOOKS)

3 Arnason, H. H. *History of Modern Art: Painting, Sculpture, Architecture*. New York: Harry N. Abrams, 1968, p. 521; color illus.

4 Ashton, Dore. *A Reading of Modern Art*. Cleveland: Case Western Reserve University Press, 1969, pp. 153–155.

5 Battcock, Gregory, ed. *Minimal Art: A Critical Anthology*. New York: E. P. Dutton, 1968, pp. 24, 27, 44; illus.

6 Geldzahler, Henry. *American Painting in the Twentieth Century*. New York: The Metropolitan Museum of Art, distributed by New York Graphic Society, 1965, pp. 97, 129, 151–152.

7 Hunter, Sam. *American Art of the 20th Century*. New York: Harry N. Abrams, 1973, pp. 191, 269, 296, 314, 316–317, 320, 324–343, 374; plates 599, 604, 623, 647, 649.

8 _____. "United States," in *New Art around the World: Painting and Sculpture*. Will Grohmann, ed. New York: Harry N. Abrams, 1966, pp. 23–25, 39, 43; plate 8.

9 *Kunst der sechziger Jahre, Sammlung Ludwig/Art of the Sixties, The Ludwig Collection*. Gert von der Osten and Horst Keller, eds. Essay by Evelyn Weiss. Cologne: Wallraf-Richartz Museum, 1969, pp. 53–54.

10 *Kunst um 1970, Sammlung Ludwig in Aachen/Art around 1970, Ludwig Collection in Aachen*. Wolfgang Becker, ed. Aachen: Neue Galerie der Stadt Aachen, 1972.

11 Mendelowitz, Daniel H. *A History of American Art*. New York: Holt, Rinehart, & Winston, 1971, p. 457.

12 Morris, Jerrold. *On the Enjoyment of Modern Art: An Illustrated Introduction to Contemporary American Styles*. Greenwich, Connecticut: New York Graphic Society, 1968; illus.

13 Rickey, George. *Constructivism: Origins and Evolution*. New York: George Braziller, 1967, pp. 59, 128, 130, 157–158, 160–161, 226.

14 Rose, Barbara. *American Art since 1900: A Critical History*. New York: Frederick A. Praeger, 1967, pp. 229–231, 248, 267; illus.

15 _____. *American Painting: The 20th Century*. Cleveland: World Publishing Company, 1970, pp. 90, 102, 108, 112, 115; illus.

16 Seuphor, Michel. *Abstract Painting: 50 Years of Accomplishment from Kandinsky to the Present*. Translated from the French by Haakon Chevalier. New York: Harry N. Abrams, 1962, p. 264; color illus.

17 *Three Generations of Twentieth-Century Art: The Sidney and Harriet Janis Collection of The Museum of Modern Art*. Foreword by Alfred H. Barr, Jr. Introduction by William Rubin. New York: The Museum of Modern Art, 1972, pp. 140–141, 174, 189, 229, 230; color illus.

18 Venturi, Robert. *Complexity and Contradiction in Architecture*. New York: The Museum of Modern Art in association with the Graham Foundation for Advanced Studies in the Fine Arts, 1966, p. 90; illus.

PERIODICALS

19 Alloway, Lawrence. "Easel Painting at the Guggenheim," *Art International* (Zürich), vol. 5, no. 10 (December 1961), pp. 26–34 (illus. p. 29). See bibl. 158.

20 _____. "Heraldry and Sculpture," *Art International* (Zürich), vol. 6, no. 3 (April 1962), pp. 52–53.

21 _____. "6 from New York," *Art International* (Zürich), vol. 5, no. 2 (March 1961), pp. 46–53. See bibl. 154.

22 _____. "On the Edge," *Architectural Design* (London), vol. 30 (April 1960), pp. 164–165 (illus.).

23 Alvard, Julien. "Quelques Jeunes Américains de Paris," *Art d'Aujourd'hui* (Paris), ser. 2, no. 6 (June 1951), pp. 24–25.

24 "Ambiguous Geometry," *Topic* (Washington, D.C.), June 9, 1962, p. 25. See bibl. 119.

25 "Art: Second Generation Abstraction," *Time* (New York), May 24, 1963, p. 78 (color illus.). See bibl. 170.

26 "Art in New York: Ellsworth Kelly at Janis," *Time* (New York), April 16, 1965, p. NY2. See bibl. 124.

27 Ashbery, John. "Art News from Paris: Kelly and Bishop," *Art News* (New York), vol. 63 (January 1965), pp. 50–51.

28 Ashton, Dore. "Anti-Compositional Attitude in Sculpture," *Studio International* (London), vol. 172 (July 1966), pp. 44–47. See bibl. 189.

29 _____. "Kelly's Unique Spatial Experiences," *Studio International* (London), vol. 170 (July 1965), pp. 40–42. See bibl. 124.

30 _____. "'The Art of the Real' at the Museum of Modern Art," *Studio International* (London), vol. 176 (September 1968), pp. 92–93 (illus.). See bibl. 213.

31 B[arnitz], J. "Ellsworth Kelly," *Arts Magazine* (New York), vol. 39, no. 9 (May–June 1965), pp. 58–59. See bibl. 124.

32 Baro, Gene. "U.S.A. at Venice," *Art and Artists* (London), vol. 1, no. 3 (June 1966), pp. 58–61. See bibl. 190.

33 Battcock, Gregory. "The Art of the Real: The Development of a Style 1948–68," *Arts Magazine* (New York), vol. 42, no. 8 (June/Summer 1968), pp. 44–47. See bibl. 213.

34 Blok, C. "Holland: New Shapes of Color," *Art International* (Lugano), vol. 11, no. 2 (February 1967), pp. 45–47. See bibl. 195.

35 B[urrey], S[uzanne]. "Ellsworth Kelly," *Arts Magazine* (New York), vol. 32, no. 1 (October 1957), pp. 56–57. See bibl. 115.

36 B[utler], B[arbara]. "Ellsworth Kelly," *Arts Magazine* (New York), vol. 30 (June 1956), p. 52. See bibl. 114.

37 Coplans, John. "Early Work of Ellsworth Kelly," *Artforum* (New York), vol. 7, no. 10 (Summer 1969), pp. 48–55 (illus.).

38 _____. "Post-Painterly Abstraction: The Long-Awaited Greenberg Exhibition Fails to Make Its Point," *Artforum* (Los Angeles), vol. 2, no. 12 (Summer 1964), pp. 4–9 (color illus.). See bibl. 177.

39 _____. "Serial Imagery," *Artforum* (New York), vol. 7, no. 2 (October 1968), pp. 34–43 (color illus.). Reprinted from catalogue of exhibition, bibl. 214.

40 Danieli, Fidel A. "Ellsworth Kelly, Ferus Gallery," *Artforum* (Los Angeles), vol. 4, no. 9 (May 1966), p. 15 (illus.). See bibl. 128.

41 Domingo, Willis. "Ellsworth Kelly," *Arts Magazine* (New York), vol. 46, no. 3 (December 1971–January 1972), p. 60. See bibl. 134.

42 Donson, Jerome A. "The American Vanguard Exhibitions in Europe," *College Art Journal* (New York), vol. 22, no. 4 (Summer 1963), pp. 242–245. See bibl. 155.

43 Drweski, Alicia. "Artificial Paradise," *Art and Artists* (Lon-

don), vol. 4, no. 1 (April 1969), pp. 50–53. See bibl. 213.

44 Elderfield, John. "Color and Area: New Paintings by Ellsworth Kelly," *Artforum* (New York), vol. 10, no. 3 (November 1971), pp. 45–49 (cover illus.). See bibl. 134.

45 Fried, Michael. "New York Letter: Ellsworth Kelly at Betty Parsons Gallery," *Art International* (Lugano), vol. 7, no. 10 (January 1964), pp. 54–56. See bibl. 120.

46 ———. "Visitors from America," *Arts Magazine* (New York), vol. 36 (December 1961), pp. 38–40. See bibl. 157.

47 Friedman, Martin Lee. "14 Sculptors: The Industrial Edge," *Art International* (Zürich), vol. 14, no. 2 (February 1970), pp. 35–36 (illus.). See bibl. 221.

48 Geldzahler, Henry. "Frankenthaler, Kelly, Lichtenstein, Olitski: A Preview of the American Selection at the 1966 Venice Biennale," *Artforum* (Los Angeles), vol. 4, no. 10 (June 1966), pp. 32–38 (illus.). Revised version of essay in catalogue of exhibition, bibl. 190.

49 ———. "Interview with Ellsworth Kelly," *Art International* (Lugano), vol. 8, no. 1 (February 1964), pp. 47–48 (illus.). Reprinted from catalogue of exhibition, bibl. 121.

50 Gindertael, R. V. "L'Art Graphique au Service de la Publicité," *Art d'Aujourd'hui* (Paris), vol. 3, no. 3–4 (February–March 1952), pp. 33–44 (illus.).

51 Greenberg, Clement. "Post-Painterly Abstraction," *Art International* (Lugano), vol. 8, no. 5–6 (Summer 1964), pp. 63–65 (illus.). Reprinted from catalogue of exhibition, bibl. 177.

52 Henning, E[dward] B. "Language of Art," *Cleveland Museum Bulletin*, no. 51 (November 1964), pp. 226–227 (illus.).

53 Hess, Thomas B. "Phony Crisis in American Art," *Art News* (New York), vol. 62 (Summer 1963), pp. 24–28, 59–60 (illus.). See bibl. 170.

54 Hoag, Jane. "Ellsworth Kelly," *Art News* (New York), vol. 66 (January 1968), p. 52. See bibl. 130.

55 Hudson, Andrew. "The 1967 Pittsburgh International," *Art International* (Lugano), vol. 11, no. 10 (December 1967), pp. 57–64. See bibl. 204.

56 Johnson, Philip. "Young Artists at the Fair and at Lincoln Center," *Art in America* (New York), vol. 52, no. 4 (August 1964), pp. 112–127 (color illus.).

57 Jürgen-Fischer, Klaus. "Neue Abstraktion," *Das Kunstwerk* (Baden-Baden), vol. 18, no. 10–12 (April–June 1965), pp. 17, 18, 115 (illus.).

58 Kerber, Bernhard. "Streifenbilder: zur unterscheidung ähnlicher Phänomene," *Wallraf-Richartz Jahr 32* (Cologne), 1970, pp. 235–256.

59 Kozloff, Max. "Art and the New York Avant Garde," *Partisan Review* (New Brunswick, New Jersey), vol. 31 (Fall 1964), pp. 535–554.

60 ———. "Geometric Abstraction in America," *Art International* (Zürich), vol. 6, no. 5–6 (Summer 1962), pp. 98–103 (illus.). See bibl. 163.

61 ———. "The Inert and the Frenetic," *Artforum* (Los Angeles), vol. 4, no. 7 (March 1966), pp. 40–44 (illus.). Revised version of lecture delivered at Bennington College, Vermont, November 29, 1965.

62 ———. "The Many Colorations of Black and White: An Example of the Jewish Museum's Recent 'Black and White' Exhibition," *Artforum* (Los Angeles), vol. 2, no. 8 (February 1964), pp. 22–25. See bibl. 173.

63 ———. "The Variables of Energy," *The Nation* (New York), May 10, 1965, pp. 513–514. See bibl. 124.

64 Kramer, Hilton. "The Abstract and the Real: From Metaphysics to Visual Facts," *New York Times*, Sunday, July 21, 1968 (illus.). See bibl. 213.

65 ———. "Episodes from the Sixties," *Art in America* (New York), vol. 58, no. 1 (January 1970), p. 59 (illus.).

66 ———. [Review] *New York Times*, July 26, 1972. See bibl. 135.

67 ———. "Realists and Others," *Arts Magazine* (New York), vol. 38 (January 1964), p. 22 (illus.). See bibl. 172.

68 Langsner, Jules. "Los Angeles Letter, Part II: February 1962," *Art International* (Zürich), vol. 6, no. 2 (March 1962), pp. 48–49.

69 Lee, David. "Serial Rights," *Art News* (New York), vol. 66 (December 1967), pp. 42–45, 68.

70 Levin, Kim. "Anything Goes at the Carnegie," *Art News* (New York), vol. 63 (December 1964), pp. 34–36 (illus.). See bibl. 181.

71 ———. "Ellsworth Kelly," *Art News* (New York), vol. 64 (May 1965), p. 10. See bibl. 124.

72 Lippard, Lucy. "Homage to the Square," *Art in America* (New York), vol. 55 (July 1967), pp. 50–57 (color illus.).

73 ———. "New York Letter: Recent Sculpture as Escape," *Art International* (Lugano), vol. 10, no. 2 (February 1966), pp. 48–58.

74 Livingston, Jane. "Los Angeles: Ellsworth Kelly at Irving Blum," *Artforum* (New York), vol. 6, no. 5 (January 1968), pp. 60–61. See bibl. 130.

75 Lynton, Norbert. "London Letter," *Art International* (Zürich), vol. 5, no. 10 (December 1961), pp. 51–54, 59 (illus.). See bibl. 157.

76 ———. "Venice 1966," *Art International* (Lugano), vol. 10, no. 7 (September 1966), pp. 83–89. See bibl. 190.

77 Mandelbaum, Ellen. "Isolable Units, Unity and Difficulty," *Art Journal* (New York), vol. 27, no. 3 (Spring 1968), pp. 256, 261, 270 (illus.).

78 Mellow, James R. "Too Much with Too Little and Too Little with Too Much," *New York Times*, November 21, 1971. See bibl. 134.

79 Melville, Robert. "Exhibitions—Paintings," *Architectural Review* (London), vol. 125 (May 1959), pp. 355–356 (illus.).

80 Menna, Filiberto. "Ellsworth Kelly," *Marcatrè* (Milan), vol. 26–29 (December 1966), pp. 155, 159 (illus.).

81 Metken, Günter. "Documenta," *Deutsche Bauzeitung* (Stuttgart), no. 102 (October 1968), p. 793. See bibl. 212.

82 "New Talent in the U.S.," *Art in America* (New York), vol. 45, no. 1 (March 1957), pp. 13–33 (illus.).

83 "Paris: French Critic Reacts," *Arts Magazine* (New York), vol. 27, no. 9 (March 1, 1953), p. 9. Statement by Michel Seuphor.

84 "Penn Center Transportation Building and Concourse," *Architectural Record* (New York), vol. 121, no. 5 (May 1957), pp. 190–196 (illus.).

85 Petlin, Irving B. "Ellsworth Kelly, Ferus Gallery," *Artforum* (Los Angeles), vol. 3, no. 8 (May 1965), p. 16. See bibl. 123.

86 Pincus-Witten, Robert. "Systemic Painting," *Artforum* (New York), vol. 5, no. 3 (November 1966), pp. 42–45. See bibl. 192.

87 Preston, Stuart. "Galleries Offer Diverse Fare," *New York Times,* Sunday, September 29, 1957. See bibl. 115.

88 "Ripe for Fashion: Tomato Tweed," *Harper's Bazaar* (New York), September 1956, pp. 58–59 (illus. of early Kelly paintings).

89 Rose, Barbara. "A.B.C. Art," *Art in America* (New York), vol. 53, no. 5 (October–November 1965), pp. 57–69.

90 _____. "The Best Game Is the End Game," *New York* magazine, April 30, 1973, pp. 92–93. See bibl. 137.

91 _____. "Beyond Vertigo: Optical Art at the Modern," *Artforum* (Los Angeles), vol. 3, no. 7 (April 1965), pp. 30–33 (color illus.). See bibl. 182.

92 _____. "'Formalists' at The Washington Gallery of Modern Art," *Art International* (Lugano), vol. 7, no. 7 (September 1963), pp. 42–43.

93 _____. "The Problem of Scale in Sculpture," *Art in America* (New York), vol. 56, no. 4 (July–August 1968), pp. 80–91 (color illus.).

94 _____. "The Sculpture of Ellsworth Kelly," *Artforum* (New York), vol. 5, no. 10 (June 1967), pp. 51–55 (color illus.).

95 _____. "The Second Generation: Academy and Breakthrough," *Artforum* (Los Angeles), vol. 4, no. 1 (September 1965), pp. 53–63.

96 Rubin, William. "Ellsworth Kelly: The Big Form," *Art News* (New York), vol. 62 (November 1963), pp. 32–35, 64–65 (color illus.). See bibl. 120.

97 _____. "Younger American Painters," *Art International* (Zürich), vol. 4, no. 1 (January 1960), pp. 24, 31.

98 Sandler, Irving H. "New York Letter," *Quadrum* (Brussels), no. 14 (1963), pp. 115–124.

99 _____. "Ellsworth Kelly," *Art News* (New York), vol. 60 (November 1961), p. 13. See bibl. 118.

100 Seitz, William C. "Mondrian and the Issue of Relationships," *Artforum* (New York), vol. 10, no. 6 (February 1972), pp. 70–75 (illus.).

101 Seuphor, Michel. "Sens et Permanence de la Peinture Construite," *Quadrum* (Brussels), no. 8 (1960), pp. 37–58 (illus.).

102 Sylvester, David. "Homage to Venus," *New Statesman* (London), June 8, 1962, pp. 839–840.

103 T[illim], S[idney], "Ellsworth Kelly," *Arts Magazine* (New York), vol. 36, no. 3 (December 1961), p. 48 (illus.). See bibl. 118.

104 _____. "Month in Review," *Arts Magazine* (New York), vol. 34, no. 1 (October 1959), pp. 48–51 (illus.). See bibl. 117.

105 _____. "What Happened to Geometry?" *Arts Magazine* (New York), vol. 33, no. 9 (June 1959), pp. 38–44.

106 Tono, Yoshiaki. "Two Decades of American Painting," *Mizue* (Tokyo), vol. 10, no. 741 (October 1966), pp. 10–30. See bibl. 194.

107 Tuchman, Phyllis. "American Art in Germany: The History of a Phenomenon," *Artforum* (New York), vol. 9, no. 3 (November 1970), p. 67 (illus.).

108 T[yler], P[arker]. "Ellsworth Kelly," *Art News* (New York), vol. 55 (Summer 1956), p. 51. See bibl. 114.

109 _____. "Ellsworth Kelly," *Art News* (New York), vol. 56 (October 1957), pp. 17–18. See bibl. 115.

110 Waldman, Diane. "Kelly, Collage and Color," *Art News* (New York), vol. 70, no. 8 (December 1971), pp. 44–47, 53–55.

111 _____. "Kelly Color," *Art News* (New York), vol. 67 (October 1968), pp. 40–41, 62–64 (color illus.). See bibl. 131.

112 Wasserman, Emily. "Ellsworth Kelly," *Artforum* (New York), vol. 7, no. 4 (December 1968), p. 58 (illus.). See bibl. 131.

EXHIBITIONS (*arranged chronologically*)

A. ONE-MAN EXHIBITIONS

113 Paris. Galerie Arnaud. "Peintures, Ellsworth Kelly," April 26–May 9, 1951.

114 New York. Betty Parsons Gallery. "Ellsworth Kelly," May 21–June 8, 1956. See bibl. 36, 108.

115 New York. Betty Parsons Gallery. "Ellsworth Kelly," September 23–October 12, 1957. See bibl. 35, 87, 109.

116 Paris. Galerie Maeght, "Ellsworth Kelly," October 24–November, 1958. Catalogue of the exhibition in *Derrière le Miroir* (Paris), no. 110 (October 1958). Text by E. C. Goossen.

117 New York. Betty Parsons Gallery. "Ellsworth Kelly: Painting and Sculpture," October 19–November 7, 1959. See bibl. 104.

118 New York. Betty Parsons Gallery. "Kelly," October 19–November 4, 1961. See bibl. 99, 103.

119 London. Arthur Tooth and Sons, "Ellsworth Kelly," May 29–June 23, 1962. Introduction by Lawrence Alloway. See bibl. 24.

120 New York. Betty Parsons Gallery. "Ellsworth Kelly: Painting and Sculpture," October 29–November 23, 1963. See bibl. 45, 96.

121 Washington, D.C. Gallery of Modern Art. "Paintings, Sculpture, and Drawings by Ellsworth Kelly," December 11, 1963–January 26, 1964. Foreword by Adelyn D. Breeskin. Interview with the artist by Henry Geldzahler. Also shown at: Institute of Contemporary Art, Boston, February 1–May 8, 1964. See bibl. 49.

122 Paris. Galerie Maeght. "Ellsworth Kelly," November 20–December, 1964. Catalogue of the exhibition in *Derrière le Miroir* (Paris), no. 149 (November 1964). Text by Dale McConathy.

123 Los Angeles. Ferus Gallery. "An Exhibition of Recent Lithography Executed in France by the Artist Ellsworth Kelly," March 9–April 5, 1965. See bibl. 85.

124 New York. Sidney Janis Gallery. "Recent Paintings by Ellsworth Kelly," April 6–May 1, 1965. See bibl. 26, 29, 31, 63, 71.

125 Paris. Galerie Maeght. "Kelly: 27 Lithographs," June 1, 1965 (opening date).

126 Kassel, West Germany, Galerie Ricke. "New Lithographs," November 22, 1965–January 5, 1966.

127 Düsseldorf, West Germany. Knoll International. "New Lithographs," 1965.

128 Los Angeles. Ferus Gallery. "New Work by Ellsworth Kelly," May 15–April 20, 1966. See bibl. 40.

129 New York. Sidney Janis Gallery. "New Work by Ellsworth Kelly," May 1–25, 1967.

130 Los Angeles. Irving Blum Gallery. "A Suite of Twelve Lithographs by Ellsworth Kelly," November 7–December 8, 1967. See bibl. 54, 74.

131 New York. Sidney Janis Gallery. "Ellsworth Kelly," October 7–November 2, 1968. See bibl. 111, 112.

132 Los Angeles. Irving Blum Gallery. "Four Paintings and One

Sculpture by Ellsworth Kelly," November 5–30, 1968.

133 Minneapolis. Dayton's Gallery 12. "Ellsworth Kelly," May 1–June 5, 1971.

134 New York. Sidney Janis Gallery. "Recent Paintings by Ellsworth Kelly," November 3–27, 1971. See bibl. 41, 44, 78.

135 Buffalo. Albright-Knox Art Gallery. "The Chatham Series: Paintings by Ellsworth Kelly," July 11–August 27, 1972. See bibl. 66.

136 Los Angeles. Irving Blum Gallery. "Ellsworth Kelly: Four Paintings, Chatham Series," March 15–April 15, 1973.

137 New York. Leo Castelli Gallery. "Ellsworth Kelly: Curved Series," April 7–28, 1973. See bibl. 90.

B. Selected Group Exhibitions

138 Boston. Boris Mirski Art Gallery. Group exhibition, Spring 1948 (catalogue not available).

138a Paris. Galerie Beaux-Arts. "Premier Salon des Jeunes Peintres," January 26–February 15, 1949. Preface by Pierre Descargues.

138b Boston. Boris Mirski Art Gallery. Group exhibition, Spring 1949 (catalogue not available).

139 Paris. Palais des Beaux-Arts de la Ville de Paris. "Réalités Nouvelles Cinquième Salon," June 10–July 15, 1950.

140 Paris. Salon des Réalités Nouvelles. "Réalités Nouvelles 1951, Numéro 5," June 1951. Statement by A. Frédo Sidès.

140a Boston Museum of Fine Arts. 75th Anniversary exhibition of the Boston Museum School, Summer 1951.

141 Paris. Galerie Maeght. "Tendance," October 1951. Catalogue of the exhibition in *Derrière le Miroir* (Paris), no. 41 (October 1951). Essay by Charles Estienne.

142 Paris. Galerie Maeght. "Tendance," October 1952. Catalogue of the exhibition in *Derrière le Miroir* (Paris), no. 50 (October 1952). Essay by Michel Seuphor.

143 Santander, Spain. Museo de Arte Contemporáneo. "Exposición Internacional de Arte Abstracto," 1953.

144 New York. The Museum of Modern Art. "Recent Drawings U.S.A.," April 25–August 5, 1956.

145 New York. Whitney Museum of American Art. "Young America 1957," February 27–April 14, 1957. Foreword by Lloyd Goodrich.

146 Brussels World's Fair. "American Art: Four Exhibitions," April 17–October 18, 1958. Organized by the American Federation of Arts. Essay by Grace McCann Morley.

147 Pittsburgh. Department of Fine Arts, Carnegie Institute. "The 1958 Pittsburgh International Exhibition of Contemporary Painting and Sculpture," December 5, 1958–February 8, 1959. Introduction by Gordon Bailey Washburn.

148 New York. Whitney Museum of American Art. "Annual Exhibition of Contemporary American Painting," December 9, 1959–January 31, 1960.

149 New York. The Museum of Modern Art. "Sixteen Americans," December 16, 1959–February 14, 1960. Organized by Dorothy C. Miller.

150 New York. David Herbert Gallery. "Modern Classicism," February 8–27, 1960.

151 Eindhoven, the Netherlands. Stedelijk van Abbemuseum. "Jongekunst uit de Collectie Dotremont/Le Jeune Peinture de la Collection Dotremont," February 20–March 27, 1960. Introduction by Michel Tapié.

152 Zürich. Helmhaus. "Konkrete Kunst," June 8–August 14, 1960. Introduction by Max Bill.

153 New York. Whitney Museum of American Art. "Annual Exhibition of Contemporary American Painting," December 7, 1960–January 22, 1961.

154 London. Arthur Tooth and Sons. "American Abstract Painters," January 24–February 18, 1961. Introduction by Lawrence Alloway. See bibl. 21.

155 Vienna. Galerie Würthle. "American Vanguard Painting," June–July 1961. Organized by the United States Information Agency. Also shown at: Zwerglgarten Pavilion, Salzburg, July–August 1961; Kalemegdan, Belgrade, September 1961; Skoplje, October 1961; Zagreb, November 1961; Moderna Galerija, Ljubljana, December 1961; Moderna Galerija, Rijeka, January 1962; American Embassy, London, March 1962; Hessisches Landesmuseum, Darmstadt, April–May 1962. See bibl. 42.

156 São Paulo. Museu de Arte Moderna. "VI Bienal: United States Pavilion," September–December 1961. Organized by the International Council of The Museum of Modern Art. Foreword by René d'Harnoncourt.

157 London. Marlborough Fine Art Ltd. "New New York Scene," October–November 1961. See bibl. 46, 75.

158 New York. Solomon R. Guggenheim Museum. "Abstract Expressionists and Imagists," October 13–December 31, 1961. Foreword and introduction by H.H. Arnason. See bibl. 19.

159 Pittsburgh. Department of Fine Arts, Carnegie Institute. "The 1961 Pittsburgh International Exhibition of Contemporary Painting and Sculpture," October 27, 1961–January 7, 1962. Introduction by Gordon Bailey Washburn.

160 Paris. Galerie Denise René. "Art Abstrait Constructif International," December 1961–February 1962. Essay by Michel Seuphor.

161 New York. Whitney Museum of American Art. "Annual Exhibition of Contemporary American Painting," December 13, 1961–February 4, 1962.

162 Chicago. Art Institute. "65th American Exhibition: Some Directions in Contemporary Painting and Sculpture," January 5–February 18, 1962. Foreword by A. James Speyer.

163 New York. Whitney Museum of American Art. "Geometric Abstraction in America," March 20–May 13, 1962. Foreword by Eloise Spaeth. Essay by John Gordon. See bibl. 60.

164 Hartford. The Wadsworth Atheneum. "Continuity and Change: 45 Abstract Painters and Sculptors," April 12–May 27, 1962. Foreword by Samuel Wagstaff, Jr.

165 Seattle World's Fair. "Art since 1950, American and International," April 21–October 21, 1962. Foreword by Norman Davis. Introduction by Sam Hunter.

166 Tokyo. Metropolitan Art Gallery. "Seventh International Art Exhibition of Japan," 1963. Statement by Tsunetaka Ueda.

167 Washington, D.C. Corcoran Gallery of Art. "28th Biennial Exhibition of Contemporary American Painting," January 18–March 3, 1963. Introduction by Hermann Warner Williams, Jr.

168 Urbana, Illinois. Krannert Art Museum, University of Illinois. "Contemporary American Painting and Sculpture 1963," March 3–April 7, 1963.

169 New York. The Green Gallery. "Robert Morris, Larry Poons, Kenneth Noland, Tadaaki Kuwayama, Don Judd, Frank Stella, Darby Bannard, Ellsworth Kelly," May 1963.

170 New York. The Jewish Museum. "Toward a New Abstraction," May 19–September 15, 1963. Preface by Alan Solomon. Introduction by Ben Heller. See bibl. 25, 53.

171 Waltham, Massachusetts. The Poses Institute of Fine Arts, Brandeis University. "New Directions in American Painting," a loan exhibition. Introduction by Sam Hunter. Shown at: Munson-Williams-Proctor Institute, Utica, New York, December 1, 1963–January 5, 1964; Isaac Delgado Museum of Art, New Orleans, February 7–March 8; Atlanta Art Association, March 18–April 22; J. B. Speed Art Museum, Louisville, Kentucky, May 4–June 7; Art Museum, Indiana University, Bloomington, Indiana, June 22–September 20; Washington University in St. Louis, October 5–30; The Detroit Institute of Arts, November 10–December 6, 1964.

172 New York. Whitney Museum of American Art. "Annual Exhibition of Contemporary American Painting," December 11, 1963–February 2, 1964. See bibl. 67.

173 New York. The Jewish Museum. "Black and White," December 12, 1963–February 4, 1964. Preface by Alan Solomon. Essay by Ben Heller. See bibl. 62.

174 Washington, D.C. National Gallery of Art. "Paintings from The Museum of Modern Art, New York," December 17, 1963–March 1, 1964. Preface by John Walker. Foreword by René d'Harnoncourt. Introduction by Alfred H. Barr, Jr.

175 Philadelphia. Institute of Contemporary Art. "The Atmosphere of '64," April 17–June 1, 1964.

176 London. The Tate Gallery. "Painting and Sculpture of a Decade, 54/64," April 22–June 28, 1964. Organized for the Calouste Gulbenkian Foundation by Alan Bowness, Lawrence Gowing, and Philip James.

177 Los Angeles County Museum of Art. "Post-Painterly Abstraction," April 23–June 7, 1964. Foreword by James Elliott. Essay by Clement Greenberg. Also shown at: Walker Art Center, Minneapolis, July 13–August 16; Art Gallery of Toronto, November 20–December 20. See bibl. 38, 51.

178 Kassel, West Germany. Museum Fridericianum. "Documenta III: Internationale Ausstellung Malerei und Skulptur," June 27–October 5, 1964. Foreword by Dr. Karl Branner. Essays by Werner Haftmann and Arnold Bode.

179 New York World's Fair. New York State Pavilion. Sculpture exhibition, 1964.

180 New York. Solomon R. Guggenheim Museum. "American Contemporary Drawings," September 17–October 25, 1964. Introduction by Lawrence Alloway. Statement by Thomas Messer.

181 Pittsburgh. Department of Fine Arts, Carnegie Institute. "The 1964 Pittsburgh International Exhibition of Contemporary Painting and Sculpture," October 30, 1964–January 10, 1965. Foreword by Gustave von Groschwitz. See bibl. 70.

182 New York. The Museum of Modern Art. "The Responsive Eye," February 23–April 25, 1965. Essay by William C. Seitz. Also shown at: City Art Museum of St. Louis, May 20–June 20; Seattle Art Museum, July 15–August 23; Pasadena Art Museum, September 25–November 7; Baltimore Museum of Art, December 14, 1965–January 23, 1966. See bibl. 91.

183 Providence, Rhode Island. Providence Art Club. "1965 Kane Memorial Exhibition; Critics' Choice: Art since World War II," March 31–April 24, 1965. Selected by Thomas B. Hess, Hilton Kramer, and Harold Rosenberg, with essays by each. Preface by William H. Jordy.

184 New York. Whitney Museum of American Art. "A Decade of American Drawings, 1955–65," April 28–June 6, 1965.

185 Basel. Kunsthalle. "Signal Exhibition: Held, Kelly, Mattmüller, Noland, Olitski, Pfahler, Plumb, Turnbull," June 26–September 5, 1965. Foreword by A. Rudlinger.

186 New York. Sidney Janis Gallery. "Pop and Op," December 1–31, 1965.

187 New York. Whitney Museum of American Art. "Annual Exhibition of Contemporary American Painting," December 8, 1965–January 30, 1966.

188 Ridgefield, Connecticut. The Aldrich Museum of Contemporary Art. "Brandeis University Creative Arts Awards 1957–66, 10th Anniversary Exhibition," April 17–June 26, 1966.

189 New York. The Jewish Museum. "Primary Structures: Younger American and British Sculptors," April 27–June 12, 1966. Introduction by Kynaston McShine. See bibl. 28.

190 Venice. "XXXIII Biennale Internazionale d'Arte," June 18–October 16, 1966. Essay by Henry Geldzahler. See bibl. 32, 48, 76.

191 Chicago. Art Institute. "68th American Exhibition," August 19–October 16, 1966. Introduction by A. James Speyer.

192 New York. Solomon R. Guggenheim Museum. "Systemic Painting," September 21–November 27, 1966. Introduction by Lawrence Alloway. See bibl. 86.

193 New York. Whitney Museum of American Art. "Art of the United States, 1670–1966," September 28–November 27, 1966. Essay by Lloyd Goodrich.

194 Tokyo. National Museum of Modern Art. "Two Decades of American Painting," October 15–November 27, 1966. Selected by Waldo Rasmussen. Essays by Irving Sandler, Lucy Lippard, and G. R. Swenson. Organized under the auspices of the International Council of The Museum of Modern Art. Also shown at: National Museum of Modern Art, Kyoto, December 10, 1966–January 22, 1967; Lalit Kala Academy, New Delhi, March 25–April 15, 1967; National Gallery of Victoria, Melbourne, June 6–July 9, 1967; and Art Gallery of New South Wales, Sydney, July 26–August 26, 1967. See bibl. 106.

195 Amsterdam. Stedelijk Museum. "Vormen van de Kleur/New Shapes of Color," November 20, 1966–January 15, 1967. Statement by E. de Wilde. Text by W. A. L. Beeren. See bibl. 34.

196 New York. Whitney Museum of American Art. "Annual Exhibition of Sculpture and Prints," December 16, 1966–February 5, 1967.

197 London. The Redfern Gallery. "Gravures Maeght Editeur," November 29, 1966–January 7, 1967. Essay by John Russell.

198 Detroit Institute of Arts. "Form, Color, Image: An Exhibition of Painting and Sculpture Presented by the Friends of Modern Art of the Founders Society," April 11–May 21, 1967. Preface by W. Hawkins Ferry. Introduction by Gene Baro.

199 Los Angeles County Museum of Art. "American Sculpture of the Sixties," April 28–June 25, 1967. Introduction by Maurice Tuchman. Essays by Lawrence Alloway, Wayne Anderson, Dore Ashton, John Coplans, Clement Greenberg, Max Kozloff, Lucy Lippard, James Monte, Barbara Rose, and Irving Sandler.

200 Montreal. Expo 67, United States Pavilion. "American Painting Now," April 28–October 27, 1967. Exhibition also

shown at: Horticultural Hall, Boston, December 15, 1967–January 10, 1968. Exhibition organized by Alan Solomon.

201 St. Paul de Vence, France. Fondation Maeght. "Dix Ans d'Art Vivant, 1955–65," May 3–July 23, 1967. Preface by François Wehrlin.

202 Krefeld, West Germany. Galerie Denise René–Hans Mayer. "Von Konstruktivismus zur Kinetik, 1917–1967," June 10–October 25, 1967. Essay by Michel Seuphor.

203 New York. Solomon R. Guggenheim Museum. "Guggenheim International Exhibition 1967, Sculpture from Twenty Nations," October 20, 1967–February 4, 1968. Introduction by Edward F. Fry.

204 Pittsburgh. Department of Fine Arts, Carnegie Institute. "The 1967 Pittsburgh International Exhibition of Contemporary Painting and Sculpture," October 27, 1967–January 7, 1968. See bibl. 55.

205 New York. Whitney Museum of American Art. "Annual Exhibition of Contemporary American Painting," December 13, 1967–February 4, 1968.

206 Frankfurt. Frankfurter Kunstverein. "Kompass III, New York: Paintings after 1945 in New York," December 30, 1967–February 11, 1968. Text by Jean Leering.

207 Ridgefield, Connecticut. The Aldrich Museum of Contemporary Art. "Cool Art," January 7–March 17, 1968.

208 New York. The Museum of Modern Art. "The Sidney and Harriet Janis Collection," January 17–March 4, 1968. Introduction by Alfred H. Barr, Jr. Also shown at: The Minneapolis Institute of Arts, May 15–July 28, 1968; The Portland Art Museum, September 13–October 13; The Pasadena Art Museum, November 11–December 15; San Francisco Museum of Art, January 13–February 16, 1969; Seattle Art Museum, March 12–April 13; Dallas Museum of Fine Arts, May 14–June 8; Albright-Knox Art Gallery, Buffalo, September 15–October 19; Cleveland Museum of Art, November 18, 1969–January 4, 1970. In Europe, also shown at: Kunsthalle, Basel, February 28–March 30, 1970; Institute of Contemporary Arts, London, May 1–31; Akademie der Künste, Berlin, June 12–August 2; Kunsthalle, Nürnberg, September 11–October 25; Württembergischer Kunstverein, Stuttgart, November 11–December 27; Palais des Beaux-Arts, Brussels, January 7–February 11, 1971; Kunsthalle, Cologne, March 5–April 18, 1971.

209 Buffalo. Albright-Knox Art Gallery. "Plus by Minus: Today's Half-Century," March 3–April 14, 1968. Foreword by Gordon M. Smith. Essay by Douglas MacAgy.

210 Eindhoven, the Netherlands. Stedelijk van Abbemuseum. "Three Blind Mice: De Collecties Visser, Peeters, Becht," April 6–May 19, 1968. Essays by Jean Leering, W. A. L. Beeren, Dr. Hubert Peeters, and Pierre Restany.

211 St. Paul de Vence, France. Fondation Maeght. "L'Art Vivant 1965–68," April 13–June 30, 1968. Essay by François Wehrlin.

212 Kassel, West Germany. Museum Fridericianum. "Documenta 4: Internationale Ausstellung," June 27–October 6, 1968. Foreword by Dr. Karl Branner. Essays by Arnold Bode, Max Imdahl, and Jean Leering. See bibl. 81.

213 New York. The Museum of Modern Art. "The Art of the Real: U.S.A., 1948–1968," July 3–September 8, 1968. Essay by E. C. Goossen. Also shown at: Grand Palais, Paris, No-vember 14–December 23, 1968; Kunsthaus, Zürich, January 18–February 18, 1969; The Tate Gallery, London, April 22–June 1, 1969. See bibl. 30, 33, 43, 64.

214 Pasadena Art Museum. "Serial Imagery," September 17–October 27, 1968. Essay by John Coplans. Also shown at: Henry Art Gallery, University of Washington, Seattle, November 17–December 22, 1968; Santa Barbara Museum of Art, January 25–February 23, 1969. See bibl. 39.

215 Honolulu Academy of Arts. "Signals in the Sixties," October 5–November 10, 1968. Introduction by James Johnson Sweeney.

216 New York. Whitney Museum of American Art. "Annual Exhibition of Contemporary American Sculpture," December 17, 1968–February 9, 1969.

217 Vancouver Art Gallery, British Columbia. "New York 13," January 21–February 16, 1969. Introduction by Doris Shadbolt. Text by Lucy Lippard. Also shown at: Norman Mackenzie Art Gallery, Regina; Musée d'Art Contemporain, Montreal; Art Gallery of Toronto.

218 New York. Whitney Museum of American Art. "Contemporary American Sculpture," April 15–May 5, 1969.

219 New York. Sidney Janis Gallery. "Seven Artists," May 1–31, 1969.

220 New York. The Museum of Modern Art. "The Nelson Aldrich Rockefeller Collection," May 26–September 1, 1969. Foreword by Monroe Wheeler. Preface by Nelson A. Rockefeller. Essay by William S. Lieberman.

221 Minneapolis. Dayton's Auditorium. "Fourteen Sculptors: The Industrial Edge," May 29–June 21, 1969. Organized by the Walker Art Center. Texts by Barbara Rose, Christopher Finch, and Martin L. Friedman. See bibl. 47.

222 New York. The Metropolitan Museum of Art. "New York Painting and Sculpture: 1940–1970," October 18, 1969–February 8, 1970. Organized by Henry Geldzahler. Essays by Henry Geldzahler, Robert Rosenblum, Clement Greenberg, William Rubin, Harold Rosenberg, and Michael Fried.

223 St. Paul de Vence, France. Fondation Maeght. "L'Art Vivant aux Etats-Unis," July 16–September 30, 1970. Essay by Dore Ashton.

224 Chicago. Museum of Contemporary Art. "Ellsworth Kelly, Morris Louis, Kenneth Noland, Frank Stella," September 12–October 26, 1970.

225 New York. Sidney Janis Gallery. "Seven Artists," December 4–31, 1970.

226 New York. Whitney Museum of American Art. "The Structure of Color," February 25–April 18, 1971. Essay by Marcia Tucker.

227 New York. The Museum of Modern Art. "Technics and Creativity: Gemini G.E.L.," May 5–July 6, 1971. Essay by Riva Castleman.

228 Philadelphia. Institute of Contemporary Art, University of Pennsylvania. "Grids," January 27–March 1, 1972. Text by Lucy Lippard.

229 Atlanta. High Museum of Art. "The Modern Image," April 15–June 11, 1972.

230 Philadelphia Museum of Art. "American Art since 1945: A Loan Exhibition from The Museum of Modern Art," September 15–October 22, 1972. Essay by Evan H. Turner.

INDEX

A page number in italics indicates an illustration.

PHOTOGRAPH CREDITS

Oliver Baker, New York, 70; Boston Museum of Fine Arts, 103 top and bottom; Barney Burstein, Boston, 15; Geoffrey Clements, New York, 56, 59, 66, 68, 71, 75, 85, 89, 91; Dayton's Gallery 12, Minneapolis, 82–83; Dumbarton Oaks Center for Byzantine Studies, Washington, D.C., 106 top left; Sante Forlano, New York, 23, 111 bottom right; Isabella Stewart Gardner Museum, Boston, 103 middle; Gemeentemuseum, The Hague, 111 middle right; Giraudon, Paris, 105 top right; Peter A. Juley and Son, New York, 110 top middle; Kate Keller, New York, 11, 14, 96 top and bottom, 97 top and bottom, 106 bottom right, 107 top right, 108 all, 109 top left, 109 middle left, 109 bottom left, 109 middle right, 111 top right, 112 bottom right; Ellsworth Kelly, New York, 12, 17, 20, 24, 26, 27, 31 top, 33, 35, 36, 42 top, 49, 53, 55, 57, 60, 63, 69, 78, 81, 86 top, 88, 100, 104 middle, 105 top left, 105 bottom right, 106 middle left, 107 middle, 109 bottom right, 110 top left, 110 middle left, 110 top right, 110 middle right, 110 bottom, 112 top left, 112 top right, 113 top; The Louvre, Paris, 113 bottom; Galerie Maeght, Paris, 47, 73, 86 bottom, 112 top middle; Robert Mates, New York, 87; James Mathews, New York, 77, 106 middle right; Metropolitan Museum of Art, New York, 104 bottom; The Museum of Modern Art, New York, 111 top left; Betty Parsons Gallery, New York, 112 middle right; Peabody Museum, Harvard University, Cambridge, Mass., 104 top; Henry Persche, Chatham, New York, frontispiece; Eric Pollitzer, Garden City, Long Island, 21, 25, 28, 37, 43, 44, 58, 84, 90, 93, 94, 95, 98, 99; Private collection, New York, 107 bottom; Walter J. Russell, New York, 34, 39, 54, 112 bottom middle, 112 bottom right; Onni Saari, New York, 79 top, 79 bottom; Sunami, New York, 105 bottom left, 107 top left, 109 top right; U.S. Army Photos, 115; Malcolm Varon, New York, 22, 31 bottom, 40, 41, 42 bottom, 48, 67, 72; John Webb, London, 51; Lawrence S. Williams, Upper Darby, Pa., 62 top, 62 bottom; Hall Winslow, New York, 64.